THEN *&* NOW

DOWNTOWN
LAKE FOREST

Opposite: In the heart of downtown Lake Forest is Market Square and its trademark fountain. (Courtesy Shirley M. Paddock.)

THEN & NOW

DOWNTOWN
LAKE FOREST

Susan L. Kelsey and
Shirley M. Paddock

For our families, friends, and everyone who loves Lake Forest.

Published by Arcadia Publishing
Charleston SC, Chicago IL, Portsmouth NH, San Francisco CA

Printed in the United States of America

For all general information contact Arcadia Publishing at:
Telephone 843-853-2070
Fax 843-853-0044
E-mail sales@arcadiapublishing.com
For customer service and orders:
Toll-Free 1-888-313-2665

Visit us on the Internet at www.arcadiapublishing.com

On the front cover: Pictured is the Lake Forest Historic Market Square, designed by American Institute of Architects (AIA) gold medalist architect Howard Van Doren Shaw (1869–1926). It was completed in 1916 by the Lake Forest Improvement Trust, which raised over $300,000 in investments to create a community center with 25 stores, 12 offices, and 28 apartments. (Historic image, courtesy Shirley M. Paddock; contemporary photograph by Ken Leone, City of Lake Forest.)

On the back cover: Please see page 72. (Courtesy Shirley M. Paddock.)

CONTENTS

ACKNOWLEDGMENTS

We would like to thank everyone who contributed information, shared their personal stories, took time to answer our questions, and donated photographs for this project. The authors made every attempt to verify facts and include relevant information. Much of the content was received from the business community, and it was our intention to try and include everyone. Please note that we found Deerpath Road spelled also as Deer Path Road, but for consistency, it will be referred to as Deerpath Road throughout the text.

This book would not be possible without the contribution of the City of Lake Forest; Arthur H. Miller and the Lake Forest College Archives; and the firm archives of Griffith, Grant and Lackie Realtors. The personal collections from the owners of Lake Forest businesses and their families provided one-of-a-kind research material that was truly appreciated. Thanks to the following businesses and families: Lake Forest Foundation for Historic Preservation; Lake Forest-Lake Bluff Historical Society; Lake Forest Library; Gorton Community Center; Maddie Bronson Dugan; Helen Dick Bronson; Dave O'Neill; James Iacubino at Wenban; Chuck, Mary Lee and Casey Helander; Kiddles Sports; John Andersen; Ellen and James Stirling; Eileen Looby; John Looby III; Jim and Tom Swarthout; Broadacre Management; the *Lake Forester*; Cathy Czerniak; Rosie Haack; Susan Banks; Willard Bunn and Baytree Bank; Brad Andersen; Anne Whipple; Leonard Turelli; Joanna Rolek; Bridget Lane; Janice Hack; Larry Ross; Sue Boucher; Malmquist family; Missy Maan de Kok; David Sweet; Linda Blaser; Fred and Mary Herlocker; Frank Farwell; John Popoli; Marion Cartwright; Elawa Farm; John Tadel; Jim and Maureen Tuohy; Michael O'Hanlon; Skip Martin; Tim Henry; Lynn Smith; Pauline Mohr; Carol Jones; Volpe family; Charles Walgreen; Jahnke family; Edward Arpee collections and writings; Susan Dart Collection (Lake Forest Library); and Lake Forest Academy. We wish to extend a special thank you to Mayor S. Michael Rummel, city manager Robert Kiely, and the great city staff.

INTRODUCTION

It is a pleasure and honor to write an introduction to this book about one of the most unique, notable, and influential suburban town centers in America—downtown Lake Forest and Market Square.

Lake Forest began as a millionaires' refuge prior to the Civil War. Whole families came out along the 1855 rail line from Chicago to live. The original 1857 plan for the town was innovative in its curvilinear streets; its educational (versus business) town center, which is now the Lake Forest College campus; and its no-growth, essentially gated community character. Businesses were all west of the tracks, with the town between the tracks and Lake Michigan to the east. Western Avenue, the business front street, was west of the tracks and not routinely visited by the estate-owning Chicago business leaders and their families, who were here year around for the schools. The stores were frequented only by their staffs. By the 1890s, however, this all-year character of the community had changed to a seasonal one, owing much to the 1895 founding of the Onwentsia club with its golf, polo, fox hunting, and tennis.

For the next 100 years, which encompassed the 1916 building of Market Square and its subsequent sale in 1984, Lake Forest's town center served one of the most fabled and exclusive communities in the nation. It catered to the rarefied tastes and expensive demands of Chicago's social and economic elite who were ensconced here especially from April to July and from September into early November. In August, many scattered to cooler spots. During this hot season, when windows could be kept down in the sooty, malodorous city 30 miles south, the community shrank down to year-round Chicago commuters and their families, college and preparatory students and faculty, and the townspeople who served all of these groups.

By 1912, the ramshackle little Lake Forest downtown was an embarrassment to the growing local estate community. The new Onwentsia crowd had to drive through the neighborhood near the station, which was far from commensurate with their stately homes along Green Bay Road and beyond. These take-charge Chicago business leaders formed the Lake Forest Improvement Trust and by 1915 were redeveloping the central business district. This became Market Square, designed by future American Institute of Architects (AIA) gold medalist and estate owner Howard Van Doren Shaw (1869–1926). Shaw followed design precedents from already completed commercial and civic blocks west of tracks, including the three-story, towered Blackler Building (1895), the Tudor city hall (1899), the Tudor railroad station east of the square (1900), the Georgian Anderson Block (1903), and the Tudor Griffith Block (1904).

Shaw inserted an eclectic blend of English town planning called arts and crafts style with a classic west-end block. The plan went through three phases (1912, 1914, and 1915). This was the first town center planned around motor vehicles, the first City Beautiful movement to be funded commercially rather than by civic buildings, and the

model for future town centers. In the next two decades, Shaw's former draftsman, Stanley D. Anderson (1896–1960) of Anderson and Ticknor, extended the style and scale of Market Square south onto Deerpath Road for two and a half blocks west of Western Avenue. Above the square's stores were apartments for those who owned or worked in the establishments below, an effort to reknit social and business life torn apart by the Industrial Revolution.

The many successful businesses themselves, not just the architecture and planning, were distinctive and adapted to this legendary elite community. The estates required specialized stores to serve their needs for chauffeur supplies (after 1904, when cars became popular), custom clothes with seamstresses, exotic and high-quality groceries, garages to repair rarefied limousines, special trim tinsmiths and metal workers, an estate focused and expert real estate office, social secretarial services, and banks. Many who worked on the estates and their families looked for recreation in town, including subsidized wholesome recreation (Young Men's Club, YWCA), less-wholesome pool halls, and, after 1933, taverns for beer and wine. There was a cottage hospital on the college campus for the support community, a library after 1899, and public schools.

Shopping in Market Square was elegant and meant to compete with city stores like the Loop's Marshall Field's, which itself moved a branch store into the west commercial building of Market Square in the 1930s. The sophisticated country sport shop provided custom elegance for women, and Smith's Men's Store, after 1937, was a country equivalent for gentlemen. And by the late 1920s, the arts and crafts English country Deer Path Inn served visitors for club activities.

Often people rented houses in Lake Forest for a few seasons before building or buying their own. One notable renter in the 1920s and 1930s was future governor and presidential candidate Adlai Stevenson, who rented the future Edward Arpee house on Washington Road. In the 1930s, Stevenson and his family built their own country place near the Des Plaines River west to Lake Forest, now the Mettawa area. College professors paid their year's rent by leasing their Campus Circle houses for the summer. This continued into the 1970s.

The town was dry before and during Prohibition (although private clubs did have facilities), but the Baytree Bank building, formerly Dr. G. G. French's Drug Store, on Western Avenue has decorations for a former speakeasy in the basement. After the repeal in 1933, there were a number of taverns for local people. Today's very successful Lantern, last of this venerable local tradition, remains on Western Avenue north of Westminster Street.

The Lake Forest Improvement Trust sold Market Square in 1984 to Broadacre Management, 15 years after the last Onwentsia horse show. The apartments were converted over to offices, and this trend continued across the district. The distinctive estate character of the community and its commercial district evolved away from serving the wealthy Chicago country club set to meeting the shopping needs of what still was Chicago's leadership suburb.

Outstanding since it opened nearly a century ago, today Market Square and Lake Forest's unique and colorful downtown are not only a wonderful community resource for those who live and shop here but also a magnet for architects, landscape architects, and planners from around the United States. Two national meetings in Chicago in September 2009, honoring the 1909 Plan of Chicago, include visits to Lake Forest's downtown and Market Square—pilgrimages to one of the most seminal, longest lasting, and successful town-planning efforts in this country. This distinction provides Lake Forest with a unique destination in which to shop, dine, spend time, and soak up the beauty and harmony of the area.

Arthur H. Miller
Archivist and librarian for Special Collections, Lake Forest College
President, Lake Forest Foundation for Historic Preservation
February 9, 2009

EARLY LAKE FOREST

1857–1894

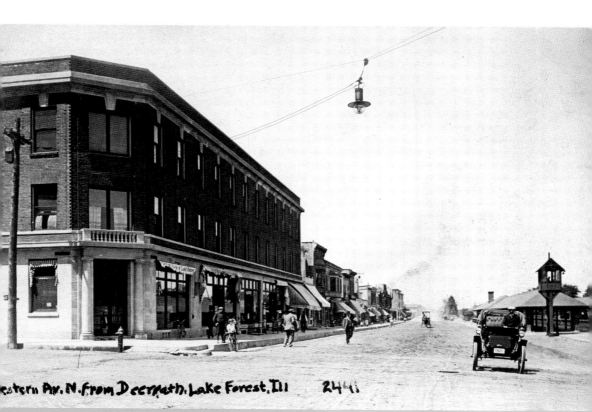

estern Av. N. from Deerpath, Lake Forest, Ill 2441

By the end of the 19th century, the city of Lake Forest had grown from a private, school focused, year-round small community to include many estates for weekend and summer residents. Businesses lined the west side of the main street, Western Avenue, providing services to the new population in Lake Forest, around 2,000 residents. (Courtesy Shirley M. Paddock.)

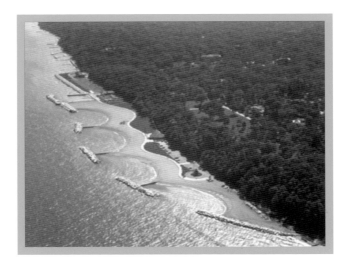

Over the past 150 years, the shore at Lake Forest has changed dramatically from being rocky with a small beach to a beautiful community recreation center. The bluff lies 90 feet above Lake Michigan, and a beautifully landscaped beach redevelopment program for the community added swimming coves, parks, a viewing peninsula, nature walks, campfires, family and group picnic pavilions, and a small boat marina in 1985 and 1986. (Historic image, courtesy Shirley M. Paddock; contemporary image, courtesy City of Lake Forest.)

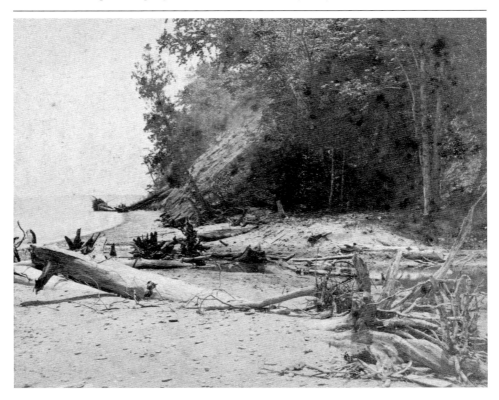

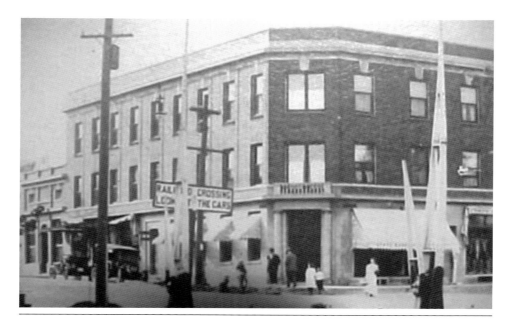

The Anderson Building was the first one constructed on the northwest corner of Deerpath Road and Western Avenue. Next to it was the First National Bank building. By the dawn of the 20th century, Western Avenue property owners that soon shaped the business district had stores, including the Carl L. Krafft Drug Store, Speidel, Dr. G. G. French's Drug Store, and O'Neill's Hardware. With the addition of the Onwentsia country club (1895) and the train station (1900), Lake Forest developed into an elite retreat from Chicago on weekends and during summers through the 1970s, and this expanded the commercial center. Today the city of Lake Forest encompasses over 19 square miles, over 7,000 households, 22,500 residents, 85 retailers, 22 restaurants, and over 400 businesses. (Historic image, courtesy Northern Trust Bank; contemporary image, courtesy Susan L. Kelsey.)

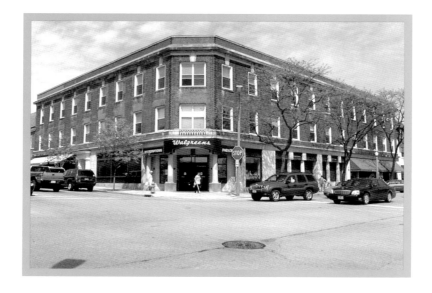

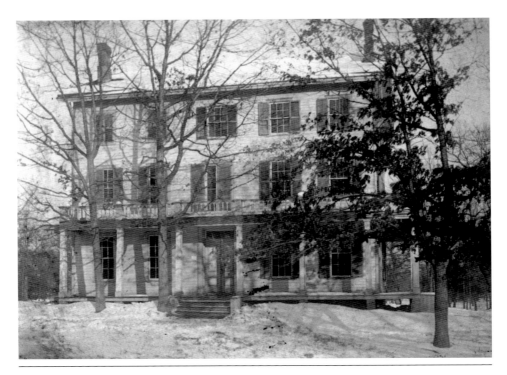

In 1858, the first hotel was built in Lake Forest and designed by Chicago architect Asher Carter on the location currently known as Triangle Park east of the central commercial district. It was the first public building in Lake Forest, used briefly by Lake Forest Academy (1858) and Lake Forest College (1878), and it also housed people buying lots in Lake Forest. Built for $6,400, local residents raised $100 subscriptions to complete the hotel. A second hotel (not shown) was built in 1871 on the bluff at Lake Michigan where the former Blair lodge was located. That hotel burned in 1877. Today the Schweppe mansion, built in 1915, stands on this beautiful lake bluff spot. (Historic image, courtesy Lake Forest College Archives; contemporary image, courtesy City of Lake Forest.)

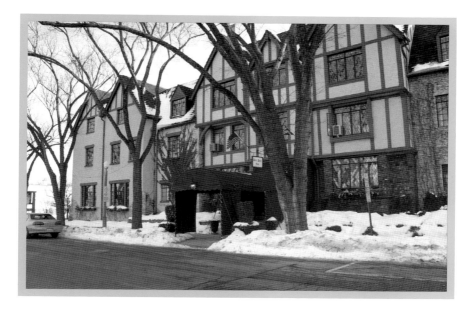

The third hotel, the original 1903 Deer Path Inn, was located on the southeast corner of Deerpath Road and McKinley Road, today a city parking lot. The inn provided lodging for the increasing number of weekend golfers and other visitors. Today the late-1920s Deer Path Inn is located west of the tracks on Illinois Avenue on the route to Onwentsia. Part of the original inn was burned in the 1930s but was restored by Anderson and Ticknor. Today the inn has 55 finely detailed chambers, meeting and banquet rooms, and is a member of the National Registry of Historic Hotels. (Historic image, courtesy Lake Forest College Archives; contemporary image, courtesy Susan L. Kelsey.)

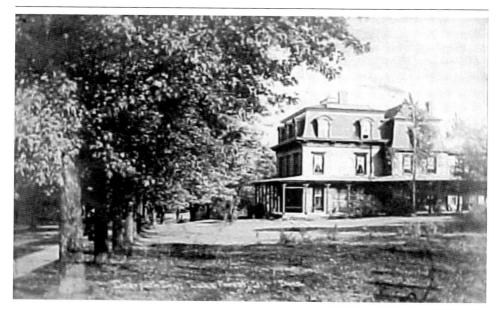

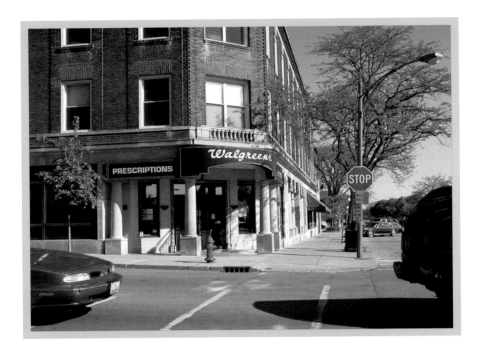

Two early Lake Forest commercial district operations were the Lind and Anderson/ Anderson General Store and the post office located at Deerpath Road and Western Avenue near the present-day Walgreens store. A 1904 fire insurance map shows the northwest corner of Deerpath Road and Western Avenue beginning to develop with the names of property owners and early businesses. Plank sidewalks framed Western Avenue at this time. (Historic image, courtesy Lake Forest Historical Society; contemporary image, courtesy Shirley M. Paddock.)

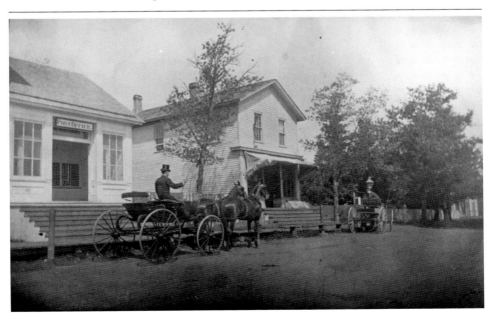

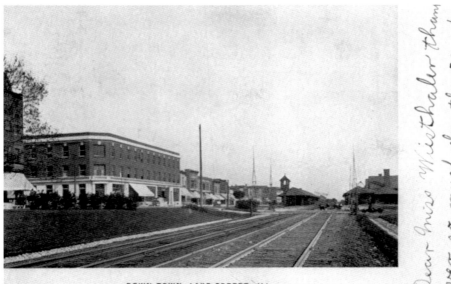

DOWN TOWN, LAKE FOREST, ILL.

Dear Miss Mistbaler than ever so much for the card you sent me sorry I did not return thy compliment before from nr. 13.

This 1907 postcard view shows the progress of that important corner with the addition of the three-story Anderson Building (Walgreens). Walgreens, a corner business for over 81 years, is the oldest, single location in the major drugstore company's history. Charles Walgreen, chief executive officer of Medinnovas Company, worked in the store in the 1970s. He recalls that the steel floor required an antenna in the stairway for transmissions to the basement. (Historic image, courtesy Shirley M. Paddock; contemporary image, courtesy Susan L. Kelsey.)

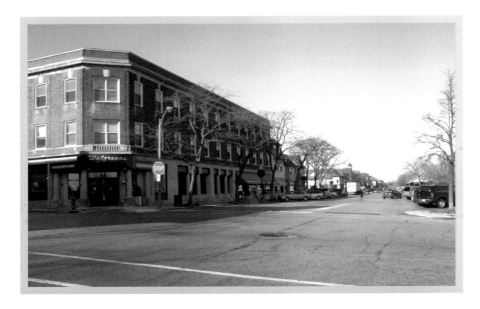

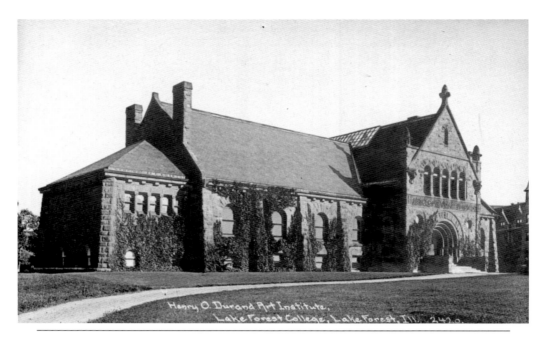

Henry O. Durand Art Institute,
Lake Forest College, Lake Forest, Ill. 2420.

The Durand Art Institute at Lake Forest College, built in 1892 by Henry Ives Cobb, has remained largely the same through the years, with a sweeping front lawn and red sandstone blocks. Today it houses the philosophy, art history, and studio art departments at the four-year liberal arts college. Highlights in the building include natural-light studios, the Sonnenschein Gallery and Albright Room for exhibits, photography darkrooms, and a digital media lab. Lake Forest College today encompasses 107 beautiful acres and has 1,368 students from 44 states and 69 countries. (Historic image, courtesy Shirley M. Paddock; contemporary image, courtesy Kaye Veazey.)

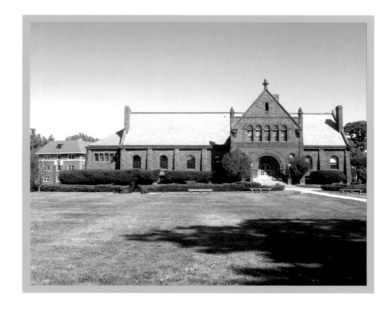

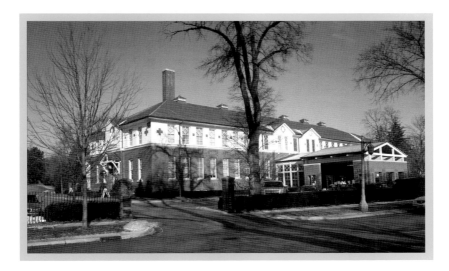

Central School was built in 1894, and Arthur H. Miller attributes its original design to Chicago architects Pond and Pond. It was renovated by James Gamble Rogers around 1900 and by Howard Van Doren Shaw in 1907. Now the Gorton Community Center, its mission is to enrich the lives of residents through education, cultural arts, and charitable services. It houses seven of Lake Forest's longtime not-for-profit volunteer organizations, such as the Lake Forest Foundation for Historic Preservation, the Deer Path Art League, Center Stage, the Volunteer Center, GLASA, LEAD, and Mothers's Trust Foundation. Notice two columns that are missing to accommodate the modern cars and buses at the center. (Historic image, courtesy Shirley M. Paddock; contemporary image, courtesy Susan L. Kelsey.)

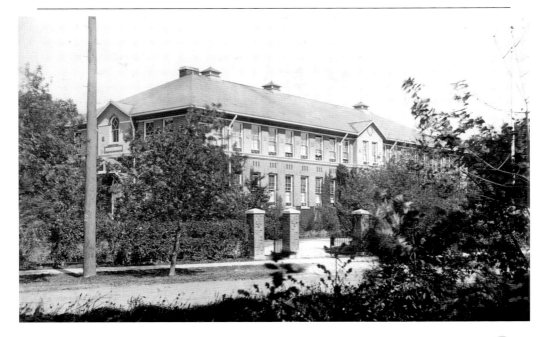

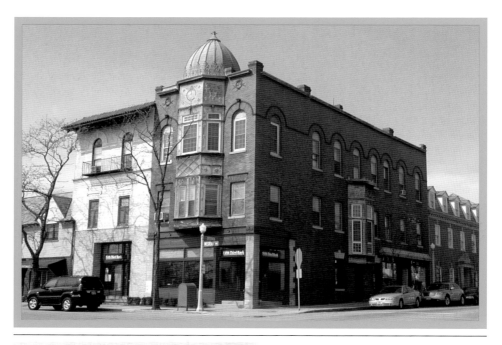

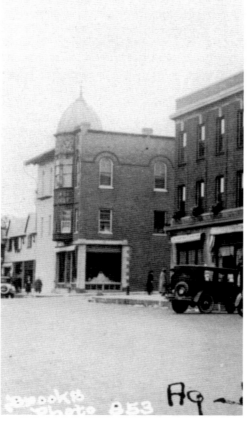

The Blackler Building, constructed in 1895 by Samuel Blackler and attributed by Arthur H. Miller to architects Pond and Pond, is located on the southwest corner of Deerpath Road and Western Avenue. The three-story structure, along with the Anderson Building on the north side, established the maximum height prevailing in Lake Forest's commercial districts today. The Blackler Building currently houses Fifth Third Bank and Therese Crowe Design, as well as rental apartments above (a scarce resource in the central business district). To the south of the Blackler Building is the 1920s Spanish-style Mann Building, designed by a Highland Park architect by that name, which houses the Perfect Setting business on the ground floor. (Historic image, courtesy Shirley M. Paddock; contemporary image, courtesy Susan L. Kelsey.)

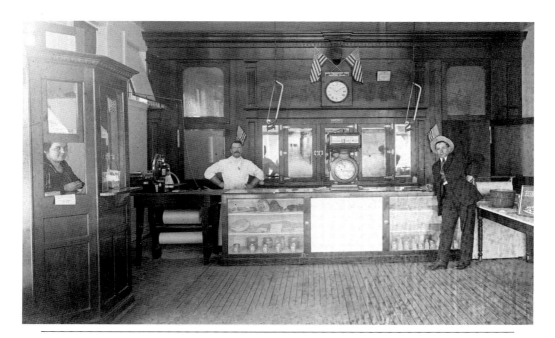

The Blackler Meat Market was one of Lake Forest's early businesses. The postcard shows the meat scales on the left and the woman cashier, a member of the Janowitz family that later operated a specialty grocery a block south on Illinois Road. This invoice from the market shows the accounts with balances typically carried for residents monthly or even annually. (Historic image, courtesy Griffith, Grant and Lackie Realtors; contemporary image, courtesy Susan L. Kelsey.)

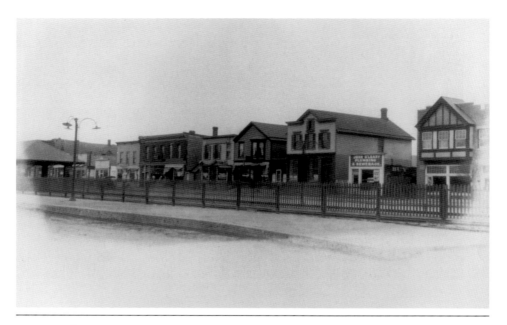

In 1868, the original O'Neill's Hardware store was located across from the train station on Western Avenue. Later the O'Neills moved their business to Westminster Street. The stone, shown recently with, from left to right, Joe O'Neill, Chad Paddock, and David O'Neill, was on the Westminster Street store prior to its 1990s demolition. The O'Neills, experienced in special-order work for estate houses, provided tin for the 1893 World's Columbian Exposition. (Courtesy Shirley M. Paddock.)

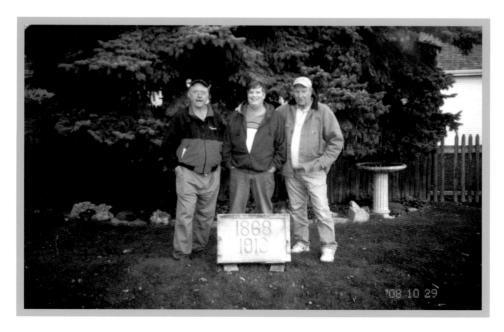

The Lake Forest fire of 1882 led to the construction of more brick buildings. One of those was the O'Neill's building at 768 North Western Avenue. The buildings included a classic brick and limestone arch designed by Howard Van Doren Shaw for a renovation around 1910. O'Neill's Hardware is fondly remembered by many Lake Foresters. Today the O'Neill family lives in Lake Forest and the building's site is now a parking lot. (Historic image, courtesy Shirley M. Paddock; contemporary image, courtesy Susan L. Kelsey.)

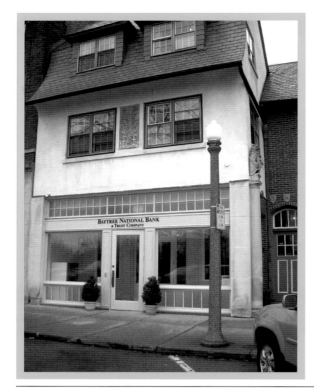

The Carl L. Krafft Drug Store was one of the early businesses in Lake Forest, located on Western Avenue and near the current Baytree Bank location. Prior to Market Square, the building stood farther back on the property. Former mayor James Swarthout fondly remembers the old soda fountain. Baytree Bank was founded in 1999 by Lake Forest residents Howard D. Adams and Alan W. Adams. (Historic image, courtesy Shirley M. Paddock; contemporary image, courtesy Baytree Bank.)

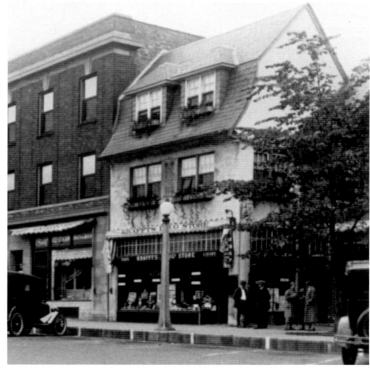

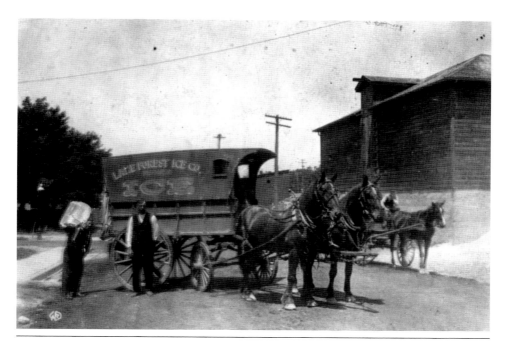

In the late 1800s, the Lake Forest Ice Company unloaded blocks of ice from freight trains that used to travel the east side tracks and distribute them by horse and carriage to families for use in preelectric refrigerators or iceboxes. The building in the photograph is believed to be the old icehouse located at Woodland Road and McKinley Road near the viaduct. Remnants of an old foundation still exist today. (Historic image, courtesy Lake Forest College Archives; contemporary image, courtesy Susan L. Kelsey.)

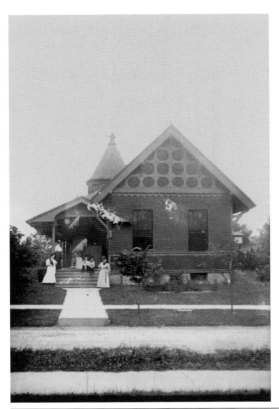

This train station from the 1800s was moved west after 1900 to Forest Avenue, opposite where the Southgate Café is today, and used initially as a Sunday school for the First Presbyterian Church. An August 18, 1917, *Lake Forester* article stated, "'Mrs. Armour Forgets Gems': Diamonds, emeralds, pearls, a dainty little packet of them, valued at about thirty thousand dollars, traveled unattended and alone for many miles in an unoccupied seat in a Northwestern train Wednesday and then started on the return trip, closely guarded by Porter Peter French. A telegram from Mrs. Armour requested that he act as messenger to return them. He did. In reply to hints as to the size of the reward, he merely smiled and declined to make a statement." (Historic image, courtesy Lake Forest College Archives; contemporary image, courtesy Shirley M. Paddock.)

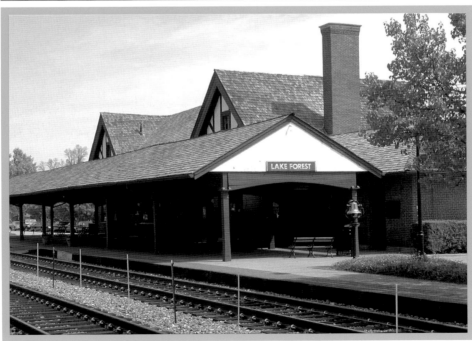

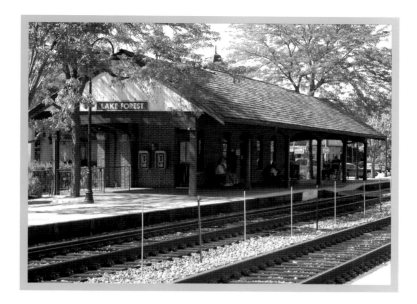

By 1900, Frost and Granger (architects Charles S. Frost and Alfred H. Grainger) designed a new train station. A postcard view shows the watchman's tower on the left side. Henry Williams, a longtime watchman active in the 1940s, blew his whistle and alerted children and families about incoming trains. Shirley Paddock currently lives in Williams's home on Noble Avenue. Today the train station still is a transportation hub for commuters and visitors. The chamber of commerce, with its Shop Local program, is located in the train station. (Historic image, courtesy Shirley M. Paddock; contemporary image, courtesy Kaye Veazey.)

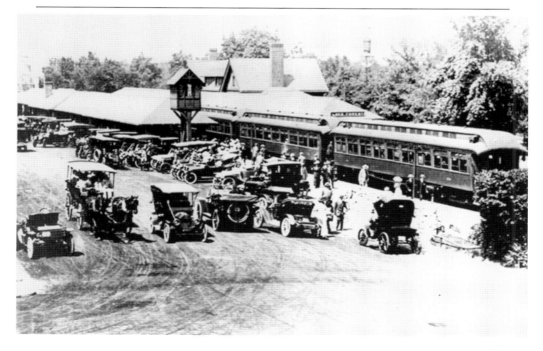

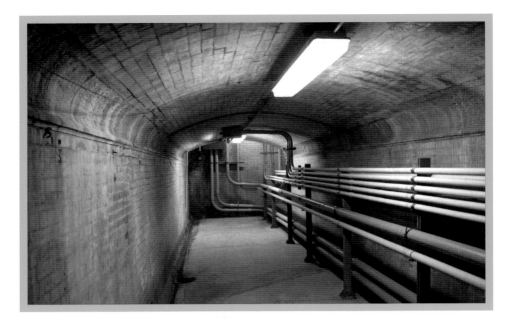

The Deerpath, the Lake Forest Special, and No. 553 were all names for the private car on the 7:36 a.m. train to Chicago. Former executives recall leaving at 8:00 a.m. and returning from the city at 5:00 p.m. on the train. The private car is still in use today. In the early 1900s, a passenger travel tunnel was used from the main train station under the tracks to the west side waiting area, which currently houses the chamber of commerce. (Historic image, courtesy Shirley M. Paddock; contemporary image, courtesy Susan L. Kelsey.)

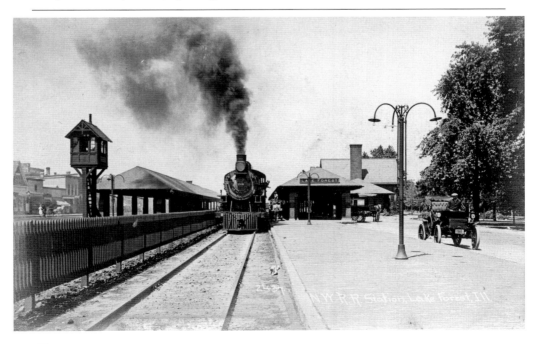

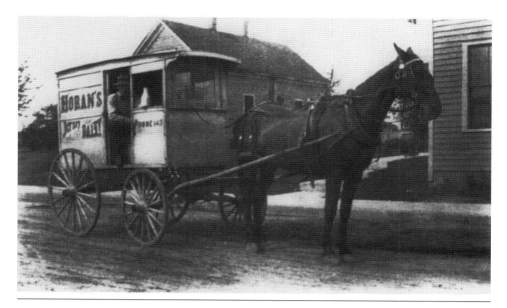

Horan's Dairy Milk was delivered by horse and buggy in 1906. Mary Horan's family, of 770 Oakwood Avenue, said they owned 90 acres near Lake Forest to house the cows. Milk was delivered from the Oakwood site where farm buildings once stood. Deliveries of Milk and other dairy products to homes continued into the 1970s, Arthur H. Miller recalls. Today Lake Forest residents shop for dairy products at the Jewel Osco store (east) or at Sunset Foods (west), which is owned by the Cortesi family. (Historic image, courtesy Lake Forest College Archives; contemporary image, courtesy Susan L. Kelsey.)

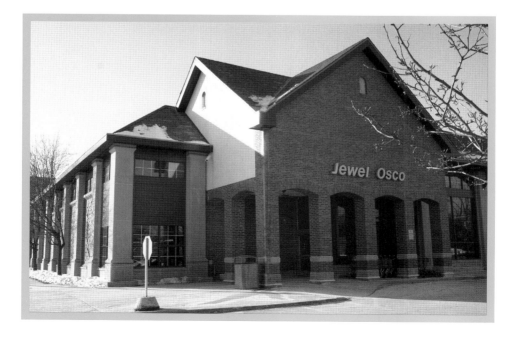

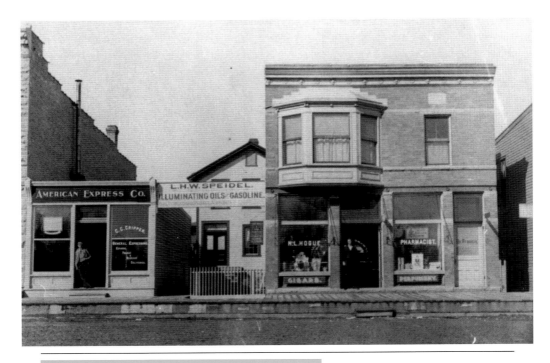

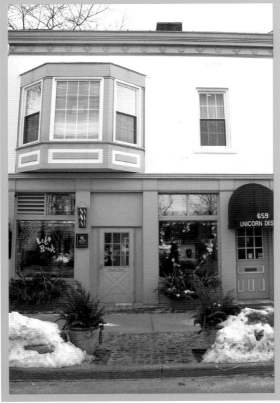

Originally located on Western Avenue in 1888, the L. H. W. Speidel Building was moved to Bank Lane when Market Square was developed in 1915. Speidel had a kerosene oil and gasoline business and several other lines. A pharmacy and cigar store occupied the building at one time. Today the Left Bank Restaurant, owned and operated by the Robert Pasquesi family, is located in the Speidel Building at 659 Bank Lane. Unicorn Designs, a custom jewelry shop, and the Lake Forest Hospital Resale Shop, run by the Women's Auxiliary Board, occupy the building now. (Historic image, courtesy City of Lake Forest; contemporary image, courtesy Susan L. Kelsey.)

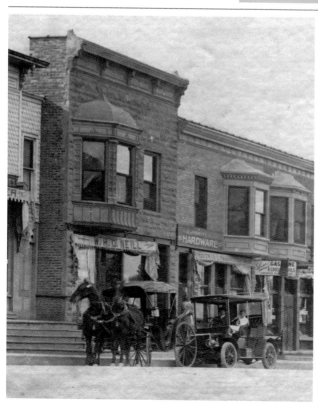

Prior to the creation of Market Square, this building stood on Western Avenue. In 1916, the building was pushed back into the Market Square courtyard and reused. It held the boiler and other utilities for the square. Today Courtyard Wines on the Square, owned by the Harkleroad family, has created a wine market and courtyard bistro for the community to enjoy in the space. (Historic image, courtesy Shirley M. Paddock; contemporary image, courtesy Susan L. Kelsey.)

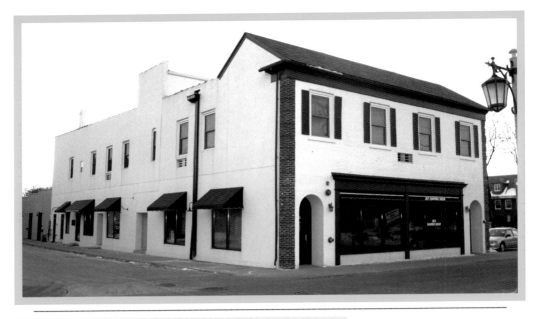

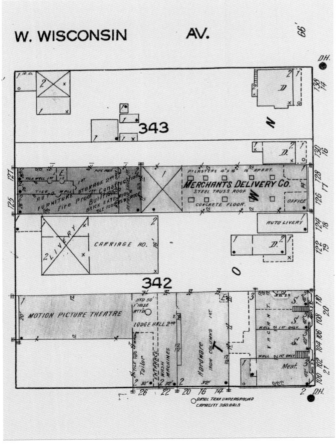

Griffith's Storage, in the left center on the map, owned by real estate entrepreneur John Griffith, was used to house estate furnishings and other items during the winter months and when owners went abroad for a year. Each fall, the estate owners brought their china, silver, and valuables to the storage facility until the following season. The outlines of the old elevator shaft can be seen today. The furniture storage building was constructed with fireproof construction. In 1917, the block also included a hardware store, a motion picture theater, a tailor, a meat market, and a carriage house. (Historic image, courtesy Shirley M. Paddock; contemporary image, courtesy Susan L. Kelsey.)

CHAPTER

An Emerging City

1895–1911

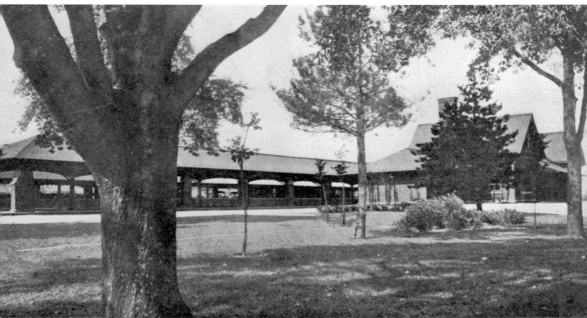

CHICAGO & NORTH-WESTERN RAILWAY STATION, LAKE FOREST, ILL.

As estates began developing around Onwentsia between 1896 and 1912, businesses grew along Western Avenue across from the train station. Around the same time, the City of Chicago was working on plans for improving and beautifying the lakefront. Architect Edward H. Bennett, formerly of D. H. Burnham and Company, who practiced on his own in the second decade of the 20th century, lived in Lake Forest and gave advice on Market Square to his in-laws, the Joneses, big backers of the project. (Courtesy Shirley M. Paddock.)

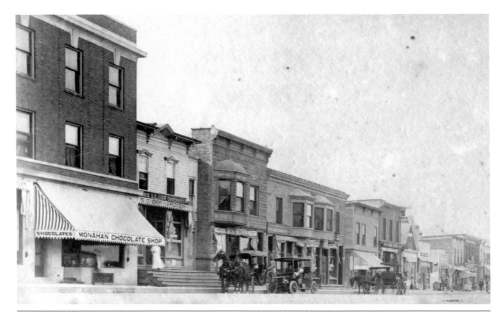

A popular photograph from the early 1900s shows Western Avenue alive with families, shoppers, and commerce. The Lake Forest business district had over 40 stores and businesses, providing products and services such as general merchandise, dry goods, oil, cigars, hardware, footwear, harnesses, chauffeur supplies, flowers, clean laundry, and real estate. The 1904 business directory listed some of these stores: James Anderson Grocery and Dry Goods, Dr. G. G. French's and Carl L. Krafft Drug Stores, the Blackler Market, Wenban's Livery and Funeral Parlor, O'Neill's and Harder's Hardware stores, Speidel's oil and gasoline, Rasmussen's Shoe Store, Gunn's Grocery, Gordon's Bicycle Shop, and others. At the dawn of the 20th century, cement sidewalks were laid. On Western Avenue, the Speidel brick buildings were later moved to Bank Lane, and the remaining storefronts were also moved to new locations around town to make room for the new Market Square. (Historic image, courtesy Shirley M. Paddock; contemporary image, courtesy Susan L. Kelsey.)

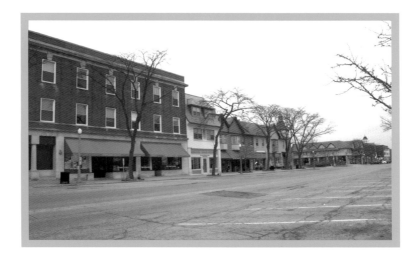

According to the October 1917 *Western Architect* magazine, many of the two-story brick and frame shanties, with false fronts and high steps were separated by a narrow Western Avenue, making a congested thoroughfare at train time. The lots, similar to this business and building, had a depth of 260 feet to a wide alley. Howard Shaw and Arthur Aldis relieved the congestion by utilizing the 300 by 400 square feet to make Market Square. The building in the pictures used to be on Western Avenue. (Historic image, courtesy Shirley M. Paddock; contemporary image, courtesy Susan L. Kelsey.)

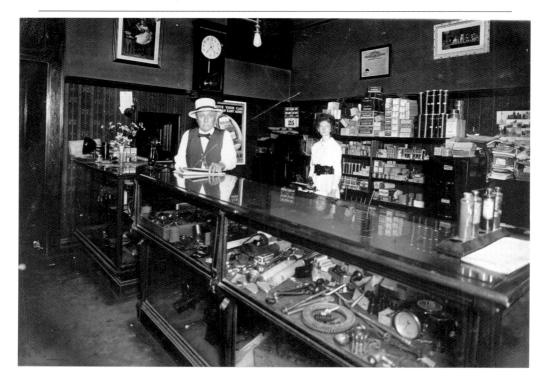

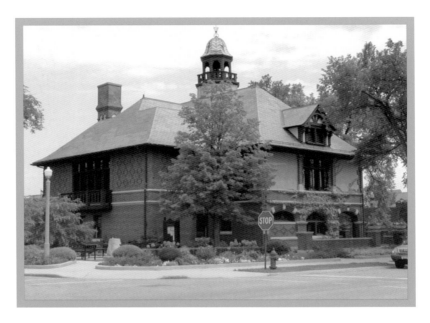

Frost and Granger designed city hall in 1898 as home to the Lake Forest Fire Department, the city administrative offices, the police department, and the Lake Forest Library. Today city hall houses the office of the city manager, the city council chambers, and the administrative offices. In May 1919, the city bought a newfangled electric siren, tested at high noon every day. Volunteer fireman came to the station when the siren sounded. In 1910, Lake Forest established its first professional fire department. Today the siren is still tested each day at noon. (Historic image, courtesy Shirley M. Paddock; contemporary image, courtesy City of Lake Forest.)

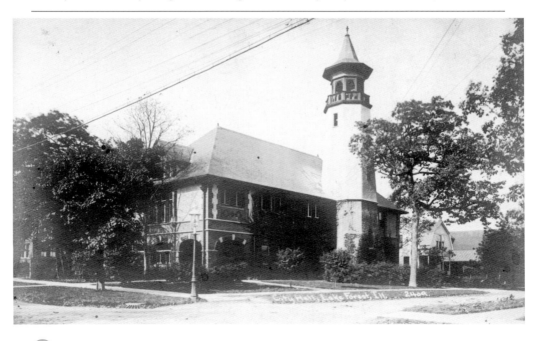

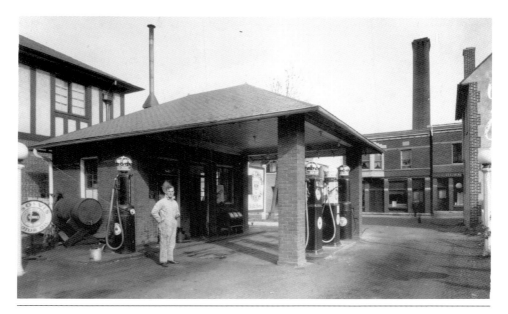

This is an early picture of the fire station, left, located on Forest Avenue just east of city hall. The fire of 1882 burned much of the downtown business district and created a need for a volunteer fire department. The fire station, built in 1900, incorporates the doors for the fire trucks to enter Forest Avenue. The fire trucks were parked in the southwest section of the buildings, and the fire hoses were upstairs in what is now the Market Club. Later the firehouse was used for a photography lab, crime lab, and supply building. Today the building is owned by Larry Ross and has four restaurants: the Southgate Café, Bank Lane Bistro, Bank Lane Bakery, and the private Market Club. They are adaptively reusing the original Frost and Granger–designed building. (Historic image, courtesy Lake Forest Historical Society; contemporary image, courtesy Larry Ross.)

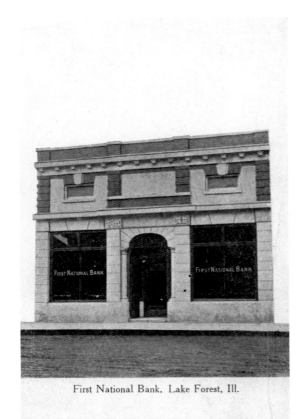

First National Bank, Lake Forest, Ill.

A predecessor of the First National Bank of Lake Forest, created in 1907, located its first banking operation on the north side of Deerpath Road, just west of the current Walgreens, now Fred's Barber Shoppe. The building no longer exists, but photographs from Northern Trust Bank show its exterior and interior during the early 1900s. The second location of the bank was on the first floor of the current Walgreens/ Anderson Building in 1915. (Historic image, courtesy John Andersen, Northern Trust Bank; contemporary image, courtesy Susan L. Kelsey.)

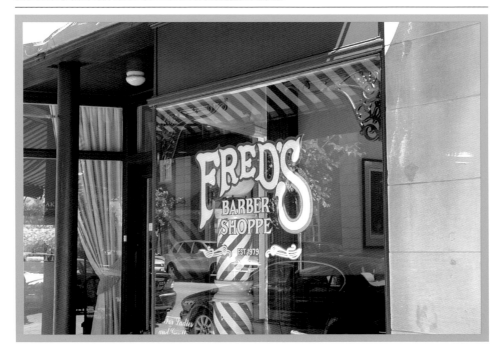

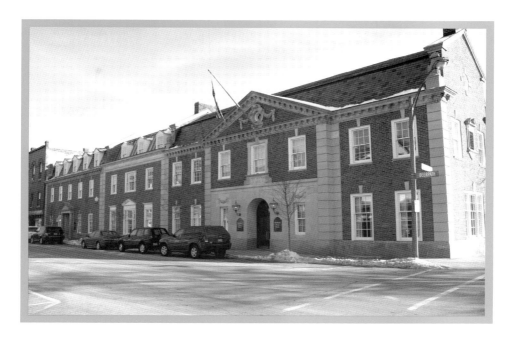

In 1916, First National Bank of Lake Forest moved into the new Market Square, a critical move to solidify other retail tenants there. The June 29, 1929, bank statement illustrates the Market Square building and lists the officers and directors of the bank at that time. By 1931, the bank relocated to a building at 265 East Deerpath Road designed by Anderson and Ticknor. (Historic image, courtesy John Andersen, Northern Trust Bank; contemporary image, courtesy City of Lake Forest.)

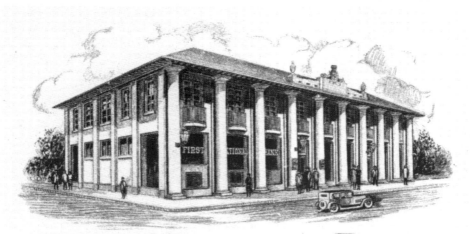

FIRST NATIONAL BANK
— MARKET SQUARE —
LAKE FOREST, ILL.

In 1899, C. G. Wenban opened a funeral home, ambulance, and livery service at 101 Deerpath Road across the street from the city hall. Pictured in the historic photograph is Wenban (standing). The horse and carriage are plowing the snow in front of the building. To the left is the ornate facade of the telephone building, since demolished. Fred Wenban strung the first telephone lines in Lake Forest and later strung them to Alice Home Hospital. (Historic image, courtesy James Iacubino at Wenban; contemporary image, courtesy Susan L. Kelsey.)

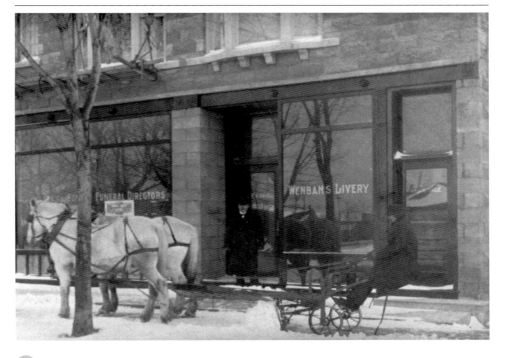

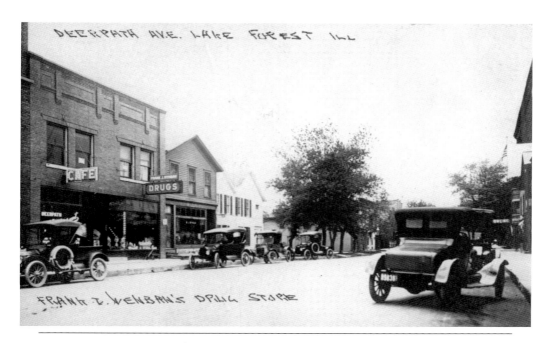

DEERPATH AVE. LAKE FOREST ILL

FRANK L. WENBAN'S DRUG STORE

Here is Wenban Drug Store on Deerpath Road in the early 1900s. The Wenban family also owned Wenban Buick and sold car and service parts in a 1930s garage adjacent to their older building. Today 225 East Deerpath houses Subway sandwiches and other stores. (Historic image, courtesy Lake Forest Historical Society; contemporary image, courtesy City of Lake Forest.)

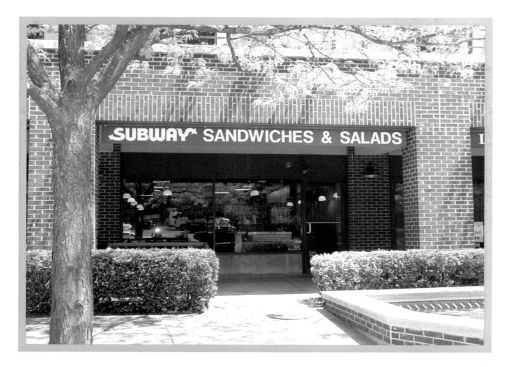

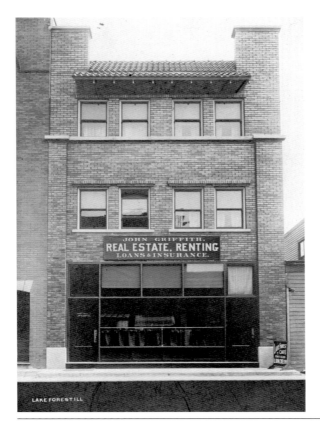

In 1903, John Griffith launched his real estate office on the south side of Deerpath Road just west of the Blackler Building, which is now the site of Northern Trust Bank. Griffith is credited with handling the largest transactions in Lake Forest, creating investments in real estate and contributing to the creation of Market Square. He had an exclusive franchise for persons seeking property for estates. This photograph shows the exterior of the first Griffith location. (Historic image, courtesy Shirley M. Paddock; contemporary image, courtesy Susan L. Kelsey.)

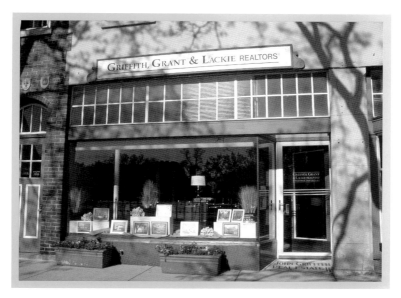

Upon the completion of Market Square in 1916, John Griffith moved his office to 678 North Western Avenue, where the successor firm, still owned in part by descendants of relations, remains today. Original records, found in the basement of the Griffith, Grant and Lackie Realtors offices, provided research materials for this book and for many other studies, dramatically increasing knowledge about the development of this unique community. The sign is still available to view today at the office on Western Avenue. (Historic image, courtesy Griffith, Grant and Lackie Realtors; contemporary image, courtesy City of Lake Forest.)

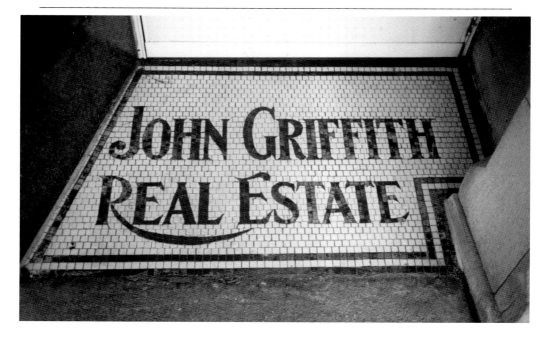

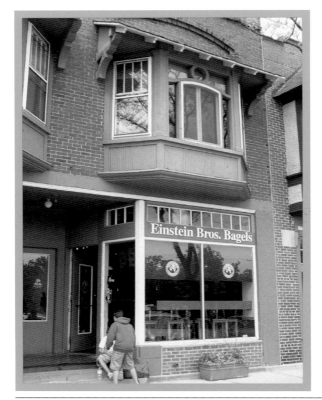

John Griffith Real Estate is now known as Griffith, Grant and Lackie Realtors and currently is operated by fourth-generation great-nephews Brad W. Andersen and Scott Lackie. (Historic image, courtesy Griffith, Grant and Lackie Realtors; contemporary image, courtesy City of Lake Forest.)

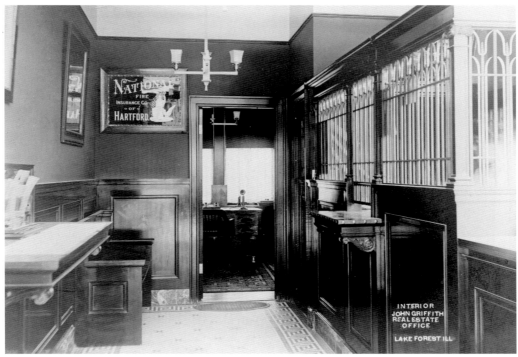

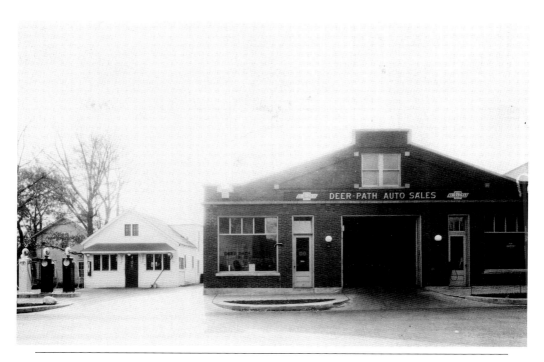

The Deer Path Garage, located at 225 East Deerpath Road and Oakwood Avenue, is now a Shell gasoline station and mini-mart. Deer Path Garage was owned by E. A. Petersen and J. P. Caspersen in 1926. The garage sold Sinclair oil and gasoline products. Service included maintenance of residents' automobiles. (Historic image, courtesy Shirley M. Paddock; contemporary image, courtesy Susan L. Kelsey.)

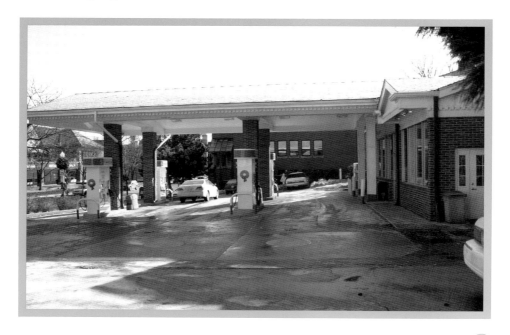

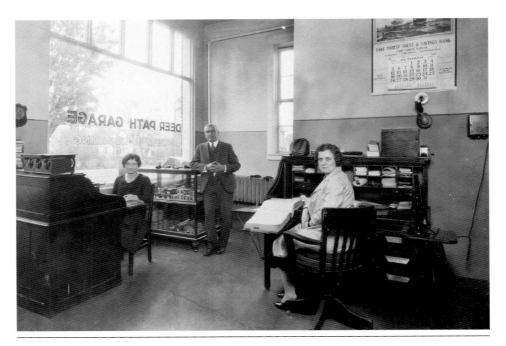

This is a 1930s view of the Deer Path Garage, located on Deerpath Road approximately where the current gasoline station is today. Standing in the photograph is John Petersen. (Historic image, courtesy Shirley M. Paddock; contemporary image, courtesy Susan L. Kelsey.)

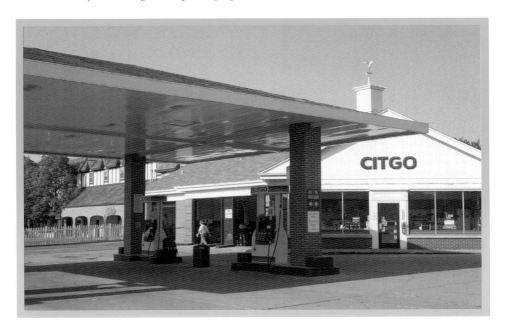

By the late 1800s, golf was growing in popularity in Lake Forest. The sport of golfing had a large impact on the business community, with lodging and services. Onwentsia Golf Club is located on Green Bay Road in Lake Forest. Seen in this photograph shared by Charles Walgreen is his great-grandfather on the right. Today golfing events are a significant leisure activity in the city of Lake Forest. (Historic image at left, courtesy Charles Walgreen; historic image below, courtesy Shirley M. Paddock.)

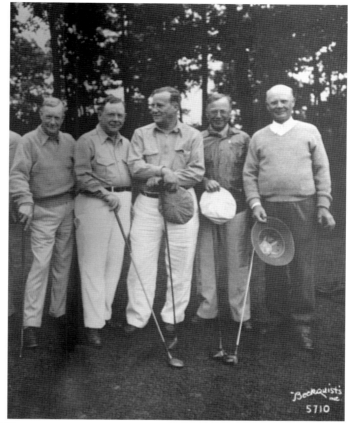

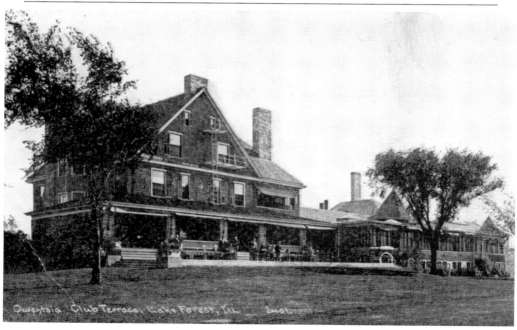

Inside the 1904 Griffith Block building, a number of different stores provided various merchandise, foods, and activities over the years. Shirley Paddock's Canadian-born father once owned a tavern at the same location. There were two bowling lanes in the back, and she remembers using them. (Historic image, courtesy Shirley M. Paddock; contemporary image, courtesy City of Lake Forest.)

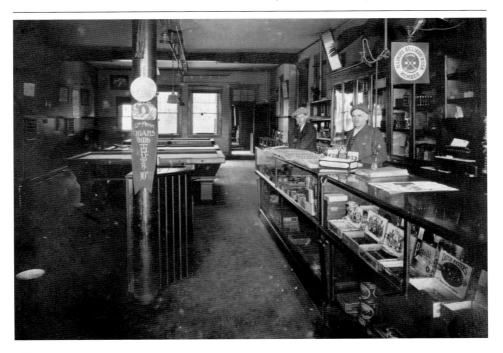

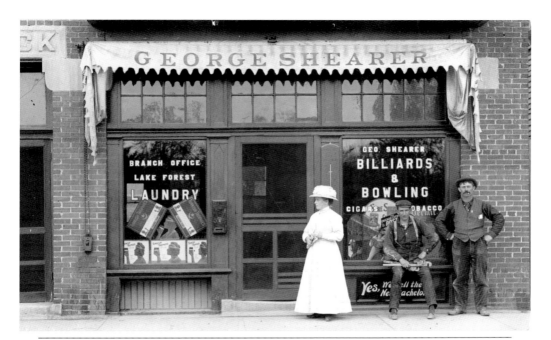

The 1904 Griffith Block building featured George Shearer Billiards and Bowling and Lake Forest Laundry. Currently the building at 736 North Western Avenue houses a part of Einstein Brothers Bagels and Mail Boxes Etc. Today, as in 1904, all businesses are located on the west side of the train tracks. (Historic image, courtesy Shirley M. Paddock; contemporary image, courtesy City of Lake Forest.)

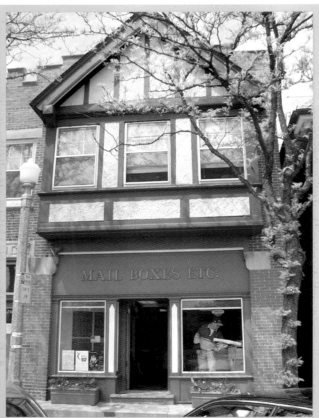

In 1904, greenhouses were a Lake Forest business. According to Edward Arpee, greenhouses and florists have been traditionally of very high caliber. Businesses of the past include Anderman, Francis Calvert (also a landscape gardener), Hild, Jahnke, and Konradt. Herman Jahnke is featured in the photograph. Today Lake Forest Flowers, owned by John A. Looby III and Eileen Looby, previously McGill's, is located at 546 North Western Avenue and specializes in floral arrangements, home decorating, and corporate events. Also, Valenti Interior's and the Clockworks are found in the same building. (Historic image, courtesy Shirley M. Paddock; contemporary image, courtesy City of Lake Forest.)

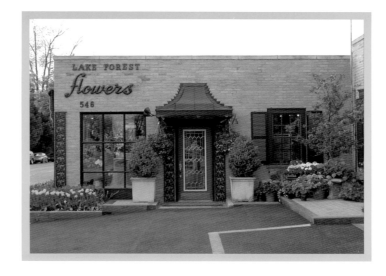

Since 1896, the *Lake Forester* newspaper has dedicated itself to community highlights and news. Managing editor David Sweet is the current local representative for a larger holding company, Pioneer Press. Other publications in the Lake Forest area are *Forest & Bluff Magazine* and the *Stentor*, the 1887-founded Lake Forest College student-run weekly newspaper, which included local news until Professor Bridgman and others launched the *Lake Forester*. (Courtesy of Pioneer Press.)

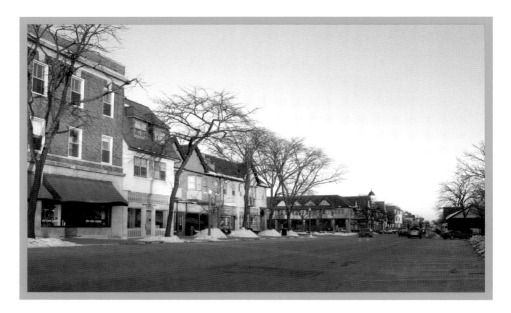

Around 1915 or 1916, dramatic changes took place on Western Avenue with the soon-to-be-developed Market Square. In this photograph, the north tower of Market Square is already there behind the buildings on Western Avenue. The Krafft drugstore exterior was under construction, bringing it forward to be even with the Anderson Building. The Speidel Buildings have yet to be moved to the courtyard and Bank Lane. (Historic image, courtesy City of Lake Forest; contemporary image, courtesy Susan L. Kelsey.)

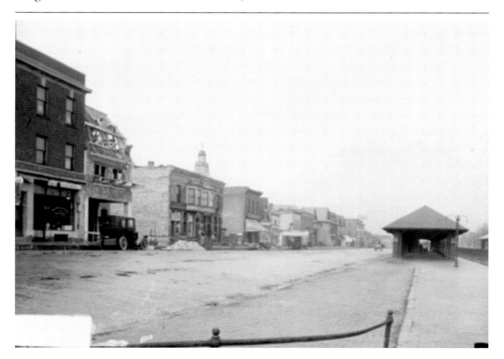

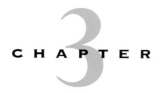

CHAPTER 3

HISTORIC
MARKET SQUARE

1912—1917

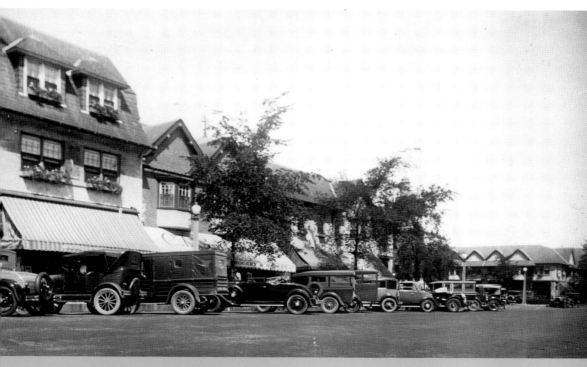

The most dramatic change to the central business district was the creation of Market Square in 1915 and 1916. Prior to the dawn of the 20th century, the majority of the buildings were wood frame, with the exception of the Blackler, Anderson, Griffith, and O'Neill's Hardware buildings, city hall, the train station, and a few others. To create Market Square, two buildings on the south end were moved to Bank Lane and a third one to the alley behind the square. The remaining buildings were either moved or demolished to create a new, beautiful shopping square. (Courtesy City of Lake Forest.)

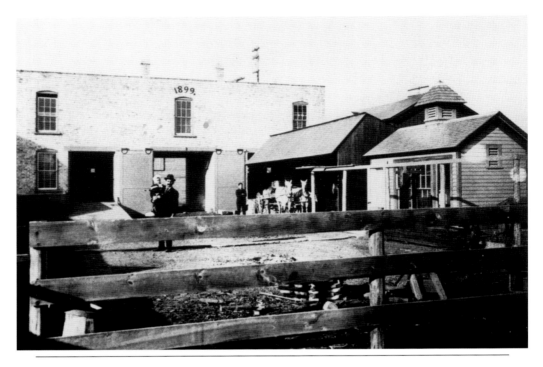

In the early 1900s west of Western Avenue, the alley was home to a livery stable, dray horses, and obsolete buildings. As the vision for Market Square materialized into a City Beautiful movement urban renewal project, local estate residents contributed to the Lake Forest Improvement Trust. (Historic image, courtesy Shirley M. Paddock; contemporary image, courtesy Ken Leone, City of Lake Forest.)

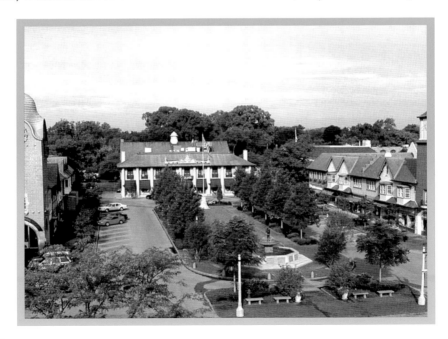

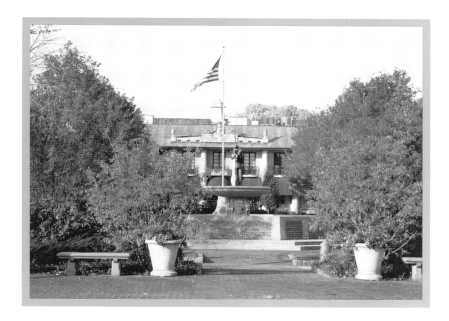

With its 25 stores and anchor tenants First National Bank of Lake Forest and Samuel Insull's Public Service utilities showroom, Market Square was the new heart of the community between the 1,300-acre portion laid out in 1857 and the new, burgeoning estate region west of Green Bay Road. The square included new lighting, a fountain, traffic posts, and benches to enjoy the view. Today Market Square's landscaped park is host to a number of community events, flag days, and is the core of the central business district of Lake Forest. (Historic image, courtesy Shirley M. Paddock; contemporary image, courtesy Ken Leone, City of Lake Forest.)

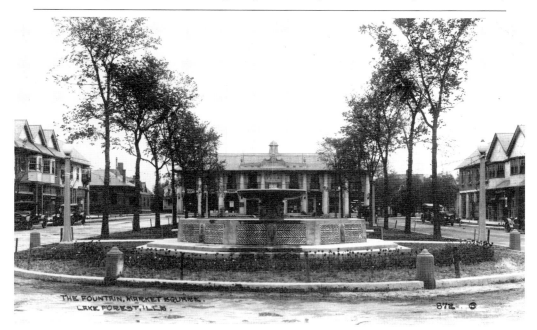

THE FOUNTAIN, MARKET SQUARE. LAKE FOREST, ILLS.

872

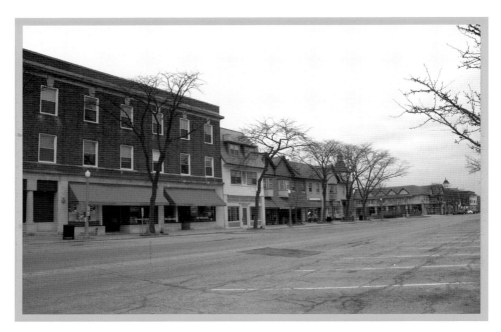

Here is Western Avenue looking north from Deerpath Road. Over the past 150 years, Lake Forest has maintained its building height in accordance with the historic scale of the Anderson, Blackler, Griffith, and O'Neill's Hardware buildings. Looking north on Western Avenue, the street is still the main thoroughfare through the city. The businesses are located on the west side of the tracks, and the train station is the fourth side of Market Square. (Historic image, courtesy Lake Forest College Archives; contemporary image, courtesy Susan L. Kelsey.)

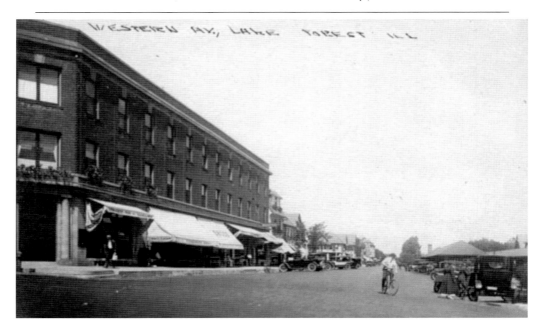

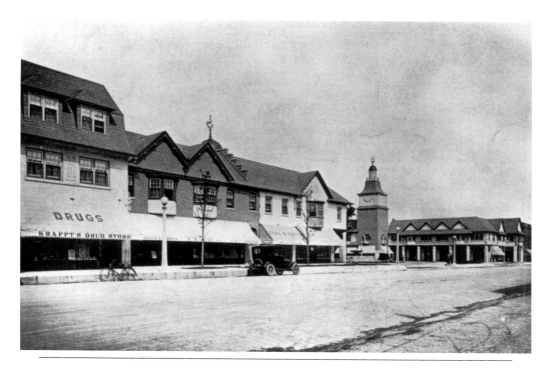

Previously called Gunn's Store and then the community store/Haan Brothers, this location is now home to Lake Forest Food and Wine. Residents recall paying their tab once a year at Haan's. Today Lake Forest Food and Wine is owned by Lee and Cindy Harkleroad and offers groceries, cheese selections, and specialty items. (Historic image, courtesy Shirley M. Paddock; contemporary image, courtesy Susan L. Kelsey.)

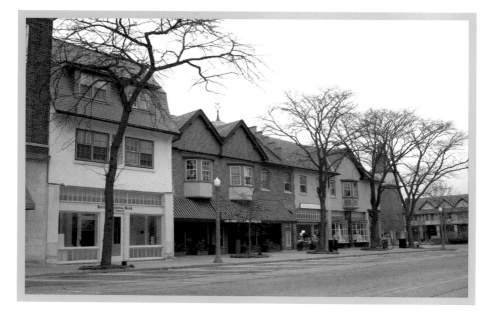

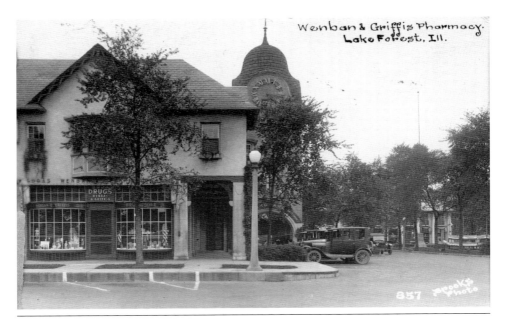

Market Square today looks similar to its original design. The Lake Forest Book Store anchors the southeast corner of the central business district. According to the October 1917 *Western Architect* magazine, with the addition of Market Square, the shop windows increased by more than 50 percent, and four new corners with their show window advantages were created. Passengers on the train, passing through Lake Forest, would see the new square and remember to stop back and spend some time in Lake Forest. (Historic image, courtesy Shirley M. Paddock; contemporary image, courtesy City of Lake Forest.)

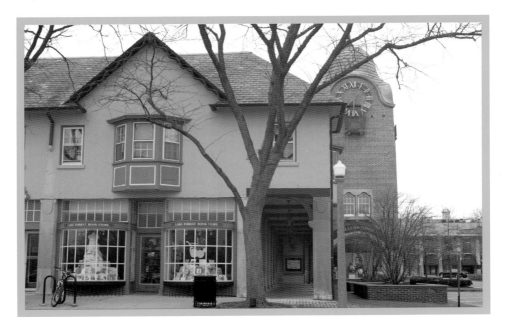

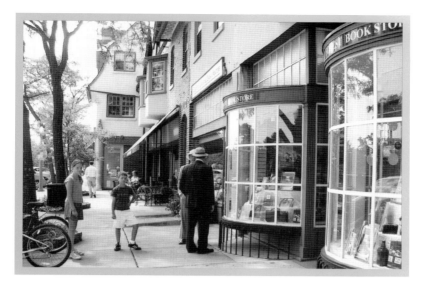

The Dr. French Pharmacy was one of the original tenants at the corner location of Market Square. Shown in the 1930s picture are Krafft drugstore, Haan Brothers Market, John Griffith Real Estate, and Dr. French Pharmacy. Today the building houses the Lake Forest Bookstore, owned by Sue Boucher. The original windows, removed for renovation in 1930 by architect Ralph Milman and reused in his house on Green Bay Road, were re-created in the 1980s restoration by architect John Vinci. The column formerly in the entrance to the Carl L. Krafft Drug Store, which moved in the 1980s and since has closed, still stands. Visit the column and see the lion and shield with its mortar and pestle. (Courtesy Lake Forest Bookstore.)

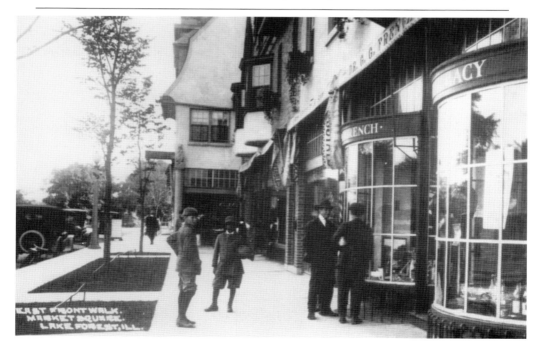

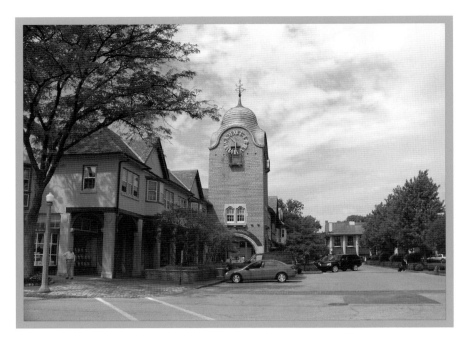

Here is an early postcard featuring the south tower in Market Square. Previously, Harder's Hardware, Wells and Copithorne, and Coast-to-Coast occupied the first-floor corner space. It is now home to Williams-Sonoma, specializing in home furnishing and cooking supplies. From the 1930s to the 1960s, architect Jerome Cerny's offices occupied the second floor of the tower. (Historic image, courtesy Shirley M. Paddock; contemporary image, courtesy City of Lake Forest.)

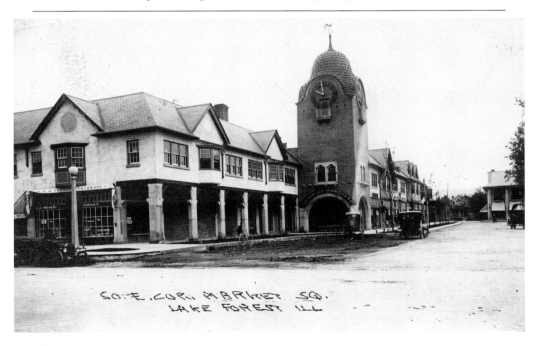

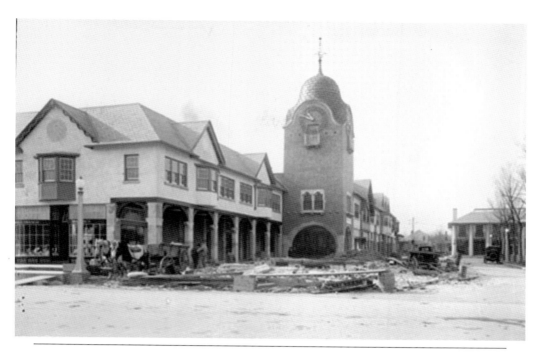

"Market Square, even from the beginning, looked as if it had just grown there naturally," wrote Susan Dart in her book *Market Square* in 1984. "A pioneer shopping center, planned and executed with an eye to beauty and usefulness, the first integrated and artfully designed shopping center in this country," wrote Edward Arpee in his book *Lake Forest Illinois: History and Reminiscences, 1861–1961.* (Historic image, courtesy Shirley M. Paddock; contemporary image, courtesy City of Lake Forest.)

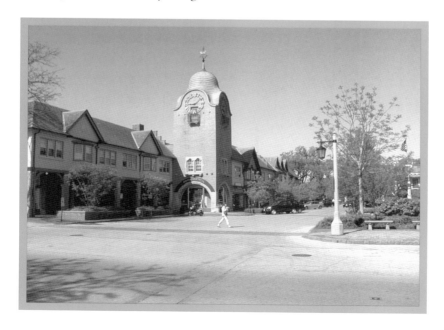

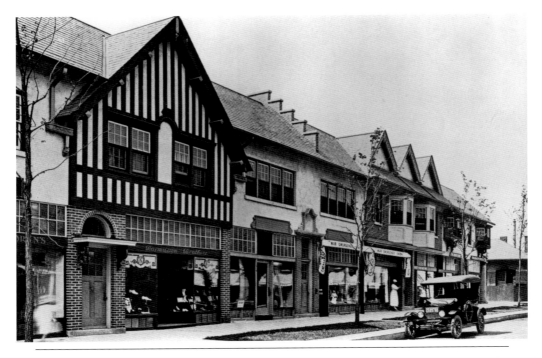

The Lake Forest Shop, owned by Ellen and James Stirling, is a third-generation family business on Market Square. In 1922, Margaret Baxter Foster, married to A. Volney Foster, started the Lake Forest Sports Shop. The Sports Shop was visionary in its time, offering current women's fashion of the day, separates dressing, and elegant evening wear. Stores prior to the Sports Shop on the south side included Rasmussen Brothers, Western Union, the War Emergency Store, and Jensen's Boot Shop, which was owned by Frank Jensen and was still in its location as late as the 1970s. Margaret's son Volney William Foster and his wife, Ellen Adair Foster, took over the Lake Forest Sports Shop in the early 1950s. (Historic image, courtesy Shirley M. Paddock; contemporary image, courtesy Susan L. Kelsey)

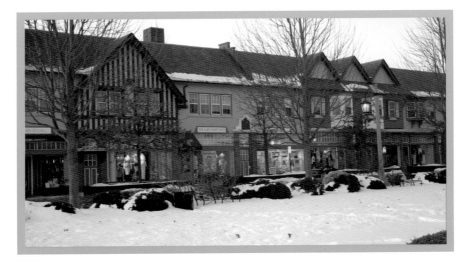

Shown is Ellen Stirling with her mother, Ellen Adair Foster. Ellen and Jim Sterling purchased the Lake Forest Shop in 1986. The Lake Forest Shop specializes in woman's fashion, from casual looks to distinctive evening wear and accessories, custom alterations and personal service. (Courtesy Ellen Stirling.)

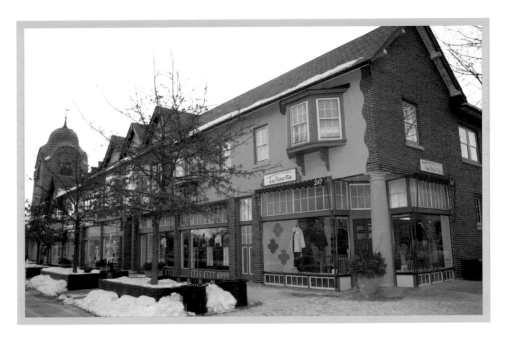

The southwest corner of Market Square is recognized by the Howard Van Doren Shaw–designed column in front of the current Talbot's Store. Previously, the location was home to the Quality Air Tire Company. The old air pump is visible on the postcard. Best Records was also in the Talbot's location. Just east of Talbot's is Penny's from Heaven and Phoebe and Frances stores. (Historic image, courtesy Shirley M. Paddock; contemporary image, courtesy Susan L. Kelsey.)

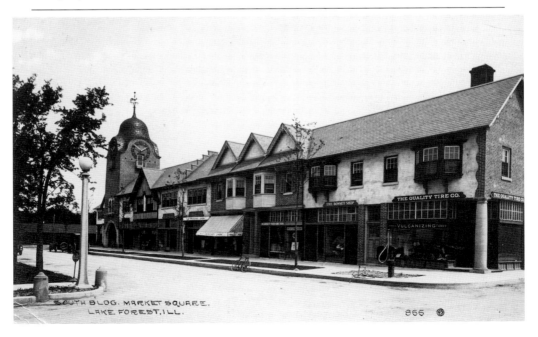

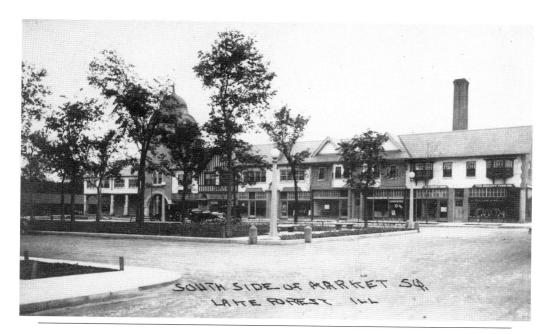

SOUTH SIDE OF MARKET SQ.
LAKE FOREST ILL

This 1916 photograph of Market Square shows the openness of the square's park, which was designed to draw shoppers in from the train. Horse carriages used both directions when traveling around the square. The Trading Post Gift Shop on the left side of the square was operated by the Women's Auxiliary Board and was well loved by the community. Bev Coleman and Leola Armour opened the volunteer-run shop in the 1920s for the benefit of Lake Forest Hospital. The shop closed in February 2005. (Historic image, courtesy Shirley M. Paddock; contemporary image, courtesy Maddie Bronson Dugan.)

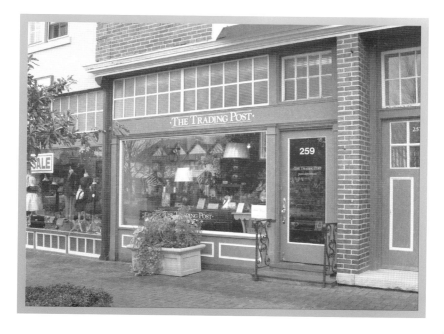

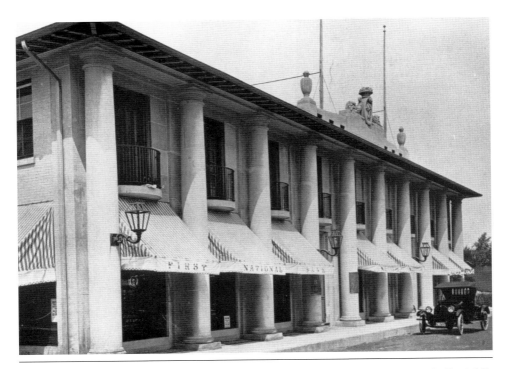

In 1916, the First National Bank of Lake Forest, now Northern Trust Bank, moved into the anchor position at Market Square. "With the bank there, lending respectability, success was assured," writes Susan Dart in her 1984 book *Market Square*. In 1931, First National Bank of Lake Forest constructed its own building on Deerpath Road, and Marshall Field's department store moved into the anchor position. Beloved by the community for years, Marshall Field's (known as Macy's for its last year) closed in 2008. The new first-floor stores include J. Crew clothiers and Blue Mercury cosmetics. (Courtesy City of Lake Forest.)

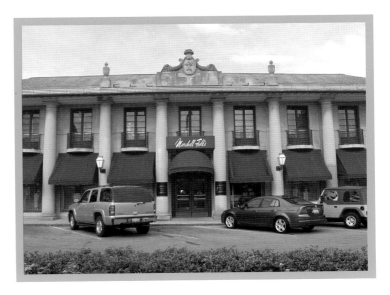

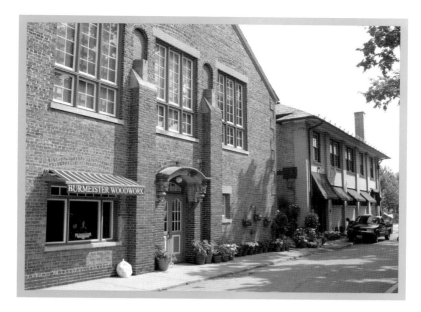

Located on Forest Avenue, residents fondly recall the recreation center, originally the 1916 Young Men's Club, having one large floor to play basketball on and to roller skate on Friday nights. Today teens play at CROYA, located at the new recreation center west on Deerpath Road. Located in the Forest Avenue building today is Burmeister Woodwork, Lake Forest Jewelry, and Amidei's Mercantino, featuring local produce from places such as the restored gardens of Elawa Farm. (Historic image, courtesy Griffith, Grant and Lackie Realtors; contemporary image, courtesy City of Lake Forest.)

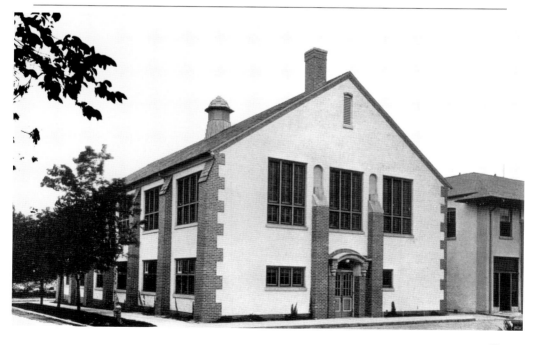

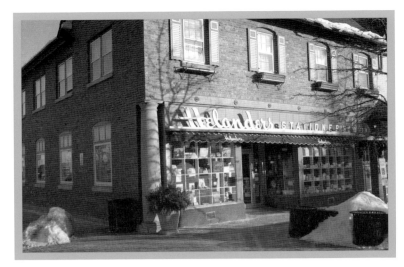

In 1916, the post office was located in what is now Helander's Stationery and Office Supplies. Chuck, Mary Lee, and Casey Helanders are the third- and fourth-generation owners. Chuck recalls that his grandfather opened the business in 1922 as a radio shop, later morphing it into an appliance and refrigerator company. In 1931, Helander's started a printing business and today attracts customers from all over metropolitan Chicago with customized stationary services. It is a treasured estate-era legacy in town. Notice the three columns that were removed in the early 1930s when National Tea moved in. (Historic image, courtesy Lake Forest Historical Society; contemporary image, courtesy Susan L. Kelsey.)

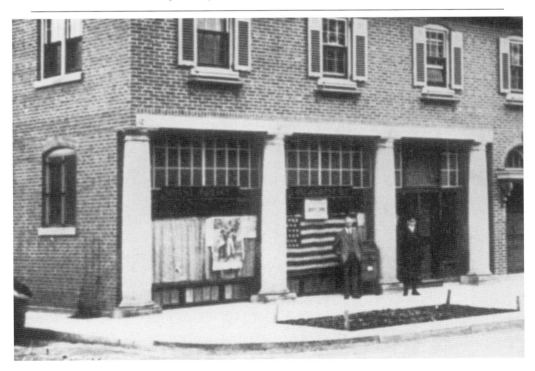

Chuck Helander and his father are seen here in 1972 celebrating their 50-year anniversary in business. He is president of the Market Square Merchants Association. He recalls Market Square having a personal secretary, Margaret Wells, who would sign personal cards and provide party planning services. Helander's worked closely with her and prominent residents. Below, from left to right, Casey, Chuck, and Mary Lee Helander are shown. (Courtesy Chuck Helander.)

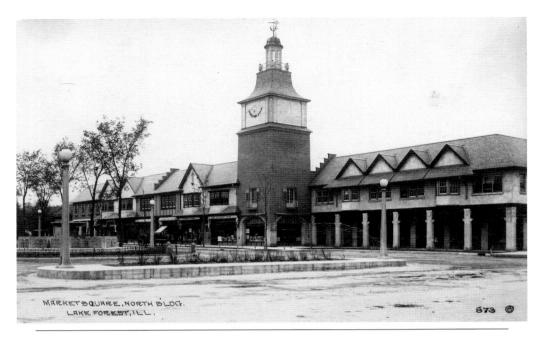

MARKET SQUARE, NORTH BLDG.
LAKE FOREST, ILL.

573

This is the north tower in Market Square, and retail stores on the north side include Kiddle's Sports, TSE Cashmere, Three Sisters, E. J. Mirage, and the Toy Station. The top of the tower is decorated with four beautiful urns and a light. (Historic image, courtesy Shirley M. Paddock; contemporary image, courtesy Susan L. Kelsey)

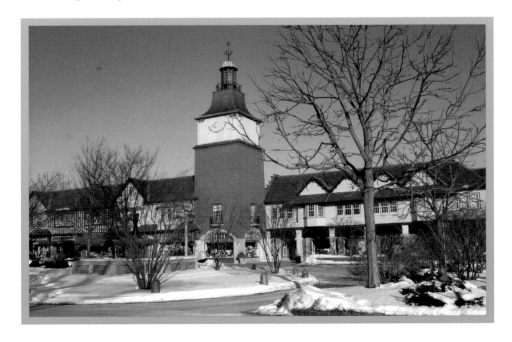

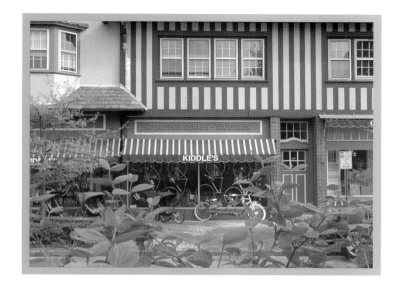

Kiddle's was opened in 1920 by Stanley Kiddle and his brothers Joseph and Charles, and it provided bike sales, rentals, and repairs. Next to Kiddle's was Barry Fitzgerald's tavern, which also sold ice cream, cigarettes, and newspapers. Today Kiddle's is owned by Jay Shlifka and his family. Kiddle's Sports offers bikes, sporting equipment, clothing, repairs, and service. (Historic image, courtesy Shirley M. Paddock; contemporary image, courtesy City of Lake Forest.)

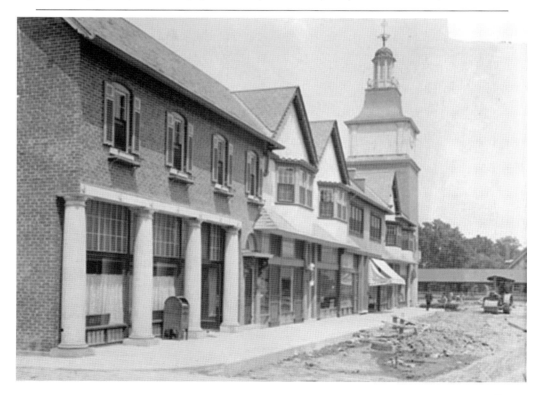

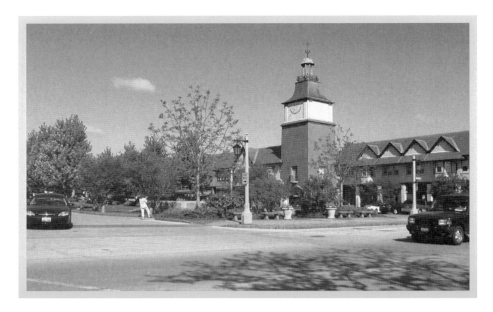

Here is the north tower of Market Square in 1917. Local residents remember Garnett's Dry Goods, an emporium for all types of items. Today the north corner houses the Toy Station, Forest Bootery, and Gerhard's (formerly the Lake Forest Bakery). Kubalsky's Clothing Store, previously located here, was popular with residents. Jack Benny was Meyer Kubalsky's son. (Historic image, courtesy Shirley M. Paddock; contemporary image, courtesy Susan L. Kelsey.)

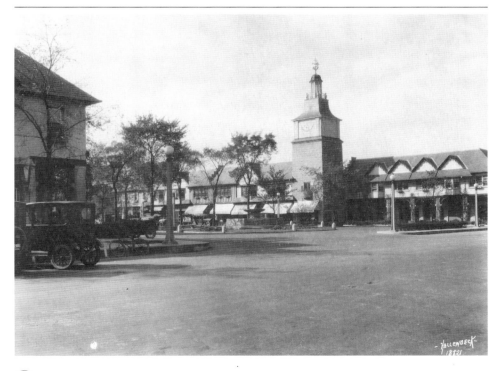

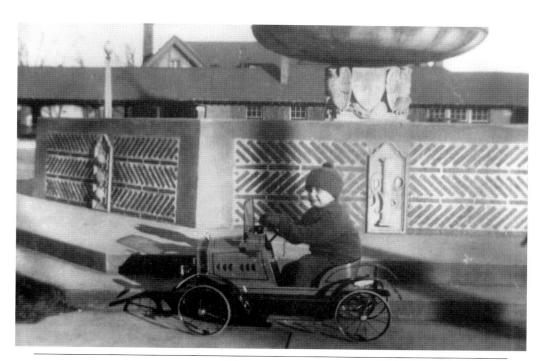

The Market Square flagpole, a tribute to World War I soldiers, was installed in 1917. It was crafted by local estate resident F. P. Smith with Wire and Iron Works in Chicago for $3.80 per lineal foot, delivered and erected. Shown in a toy car is Fred H. Berghorn in 1924, today a local resident. (Historic image, courtesy Lake Forest College Archives; contemporary image, courtesy Susan L. Kelsey.)

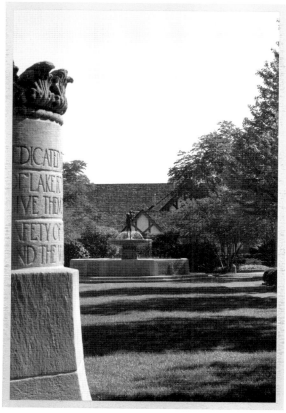

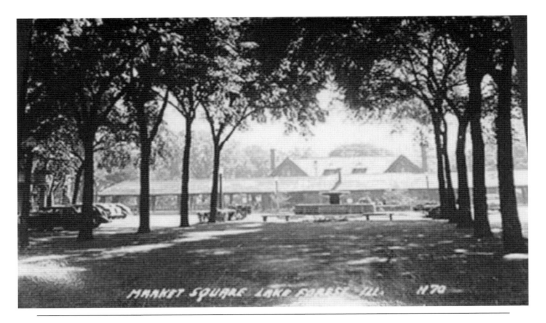

Looking at Market Square east toward the train station, visible are the tall, old elm trees, long since gone, framing the green lawn. Today the square appears as it was rehabilitated by Market Square 2000, a group organized by the Lake Forest Garden Club to raise the funds to restore the park, the roadways, the infrastructure, and the fountain, as well as replant the spaces. Popular events held at the square include the annual tree-lighting event the Friday evening after Thanksgiving, the Labor Day weekend Deer Path Art League art show, parades (especially on Lake forest Day, the first Wednesday in August), government celebrations, and summer concerts. (Historic image, courtesy Shirley M. Paddock; contemporary image, courtesy City of Lake Forest.)

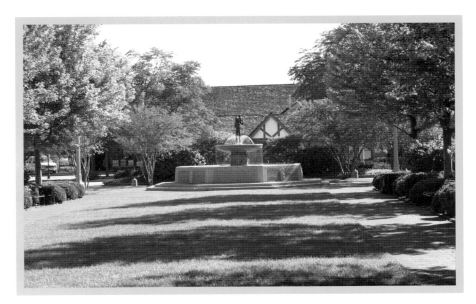

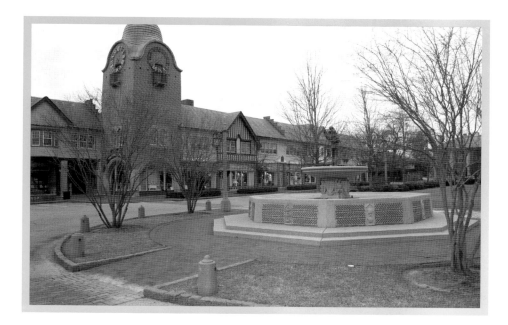

Looking at Market Square from the train station, one can view the south tower with the clock. According to Susan Dart's book, *Market Square*, the tower was Bavarian or Tyrolean in style with a curved copper dome. The English half-timbered construction is visible over the current Lake Forest Shop store and Howard Van Doren's signature basket of fruit is designed between the windows. The second floor housed apartments originally. Today the second floor houses offices and Lake Forest businesses. (Historic image, courtesy Shirley M. Paddock; contemporary image, courtesy Susan L. Kelsey.)

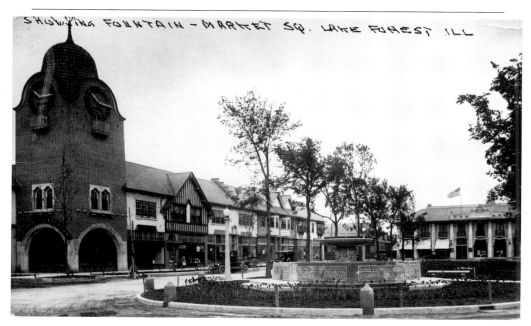

In 1904, John Griffith constructed the Tudor building at 768 North Western Avenue with retail space and apartments. Over the years, a number of businesses have been in the building, including bowling alleys, cigar shops, a dentist office, and others. Today Einstein Brothers Bagels and Mail Boxes Etc. occupy the space. (Courtesy City of Lake Forest.)

CHAPTER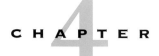

A SPECIAL PLACE
1918–2009

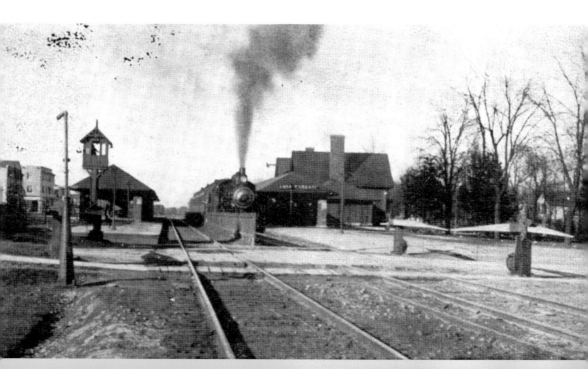

This 1906 postcard says it all: "Where we leave and where we return." (Courtesy Shirley M. Paddock.)

77

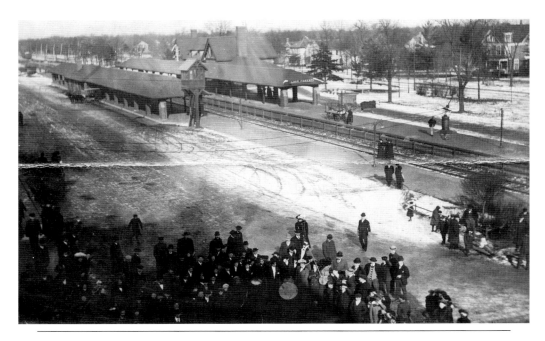

Luggage trucks were typically used in Lake Forest to transport items between Chicago, Lake Forest, and other destinations. Helen Dick Bronson, a lifelong Lake Forest resident and Albert B. Dick descendant, recalls sending her luggage on the train to her boarding school in Massachusetts. Most of the luggage trunks displayed at the train station are from original Lake Forest families. Sutton Delivery took the trunks to the estates. (Historic image, courtesy Shirley M. Paddock; contemporary image, courtesy Susan L. Kelsey.)

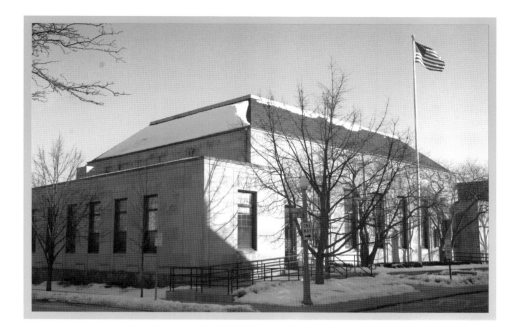

By the 1930s, the stately post office, designed by architect Ralph Milman in the art deco style, was built near Market Square. Local residents recall the post office was built largely to accommodate the vast number of Sears catalogs being received. At that time, Gen. Robert E. Wood was the chairman of Sears and a local resident. (Historic image, courtesy Shirley M. Paddock; contemporary image, courtesy Susan L. Kelsey.)

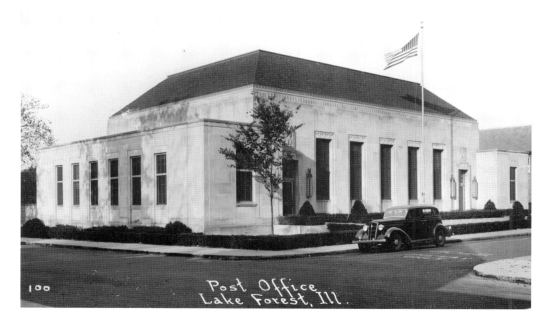

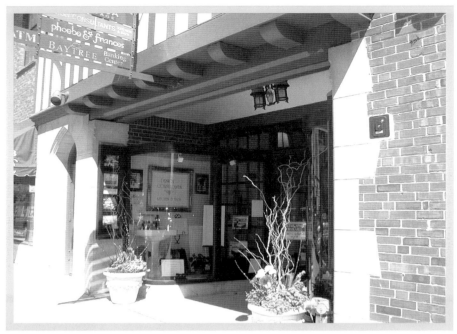

According to Edward Arpee, the Deerpath Theater was planned in 1926 and finished in 1928. Lake Forest residents fondly remember the theater as a weekly destination. Today the theater building houses offices and retail shops such as the Green Teaist, Wired on Bank Lane, and other Lake Forest businesses. (Historic image, courtesy City of Lake Forest; contemporary image, courtesy Susan L. Kelsey.)

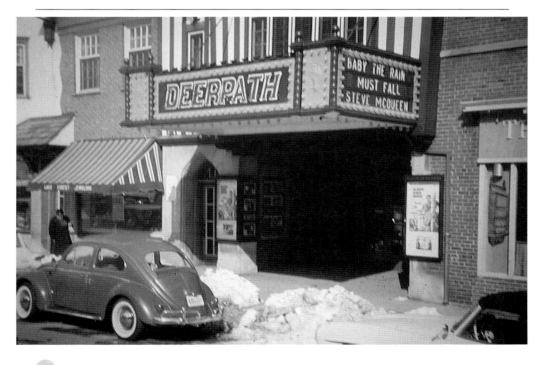

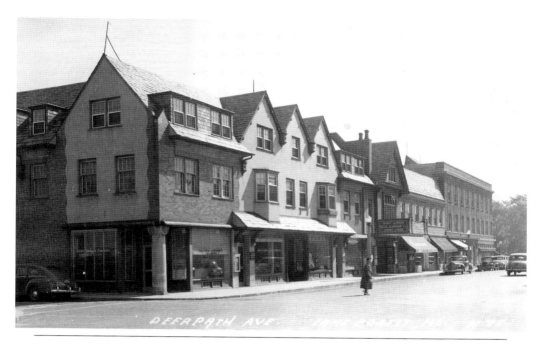

The Anderson Trust's building (on part of the early-1860s Anderson farm), constructed in 1927 and located at 270 Deerpath Road, housed a movie theater, four stores, 15 offices, and four apartments. In the theater, two carved oak screens hid the organ pipes, and oak panels were throughout the auditorium. Today the building hosts Sweets, the Homemade Pizza Company, Finishing Touches Design, Lake Forest Jewels, and Fred's Barber Shoppe. Also nearby is Wired on Bank Lane and the Green Teaist. (Historic image, courtesy Shirley M. Paddock; contemporary image, courtesy City of Lake Forest.)

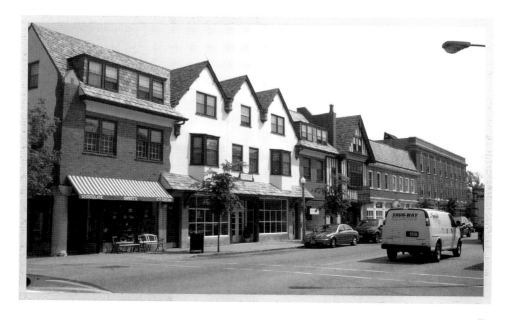

On the northwest corner of Deerpath Road and Bank Lane, Dimitrios Jewelers, Arabesque Dancewear, and Blink Optical are now Lake Forest businesses. Previously, the building housed Henderson's Bowling Lanes, McCormick's Tavern, and, in the 1970s, a Baskin-Robbins ice-cream shop. (Courtesy City of Lake Forest.)

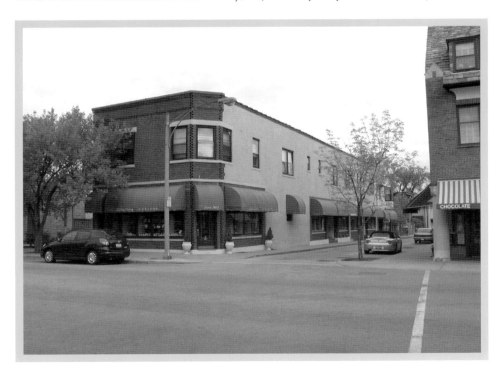

A SPECIAL PLACE: 1918–2009

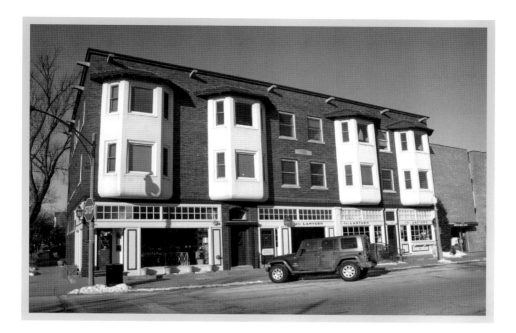

The Lantern Restaurant, owned by the Tiffany family, has been in Lake Forest for over 34 years. Ray Van Eeckhout and Jerry Boutin recall the barbershop downstairs and proprietors Jack Huhnke and Don and Frank Tiffany's contribution to the city of Lake Forest over many years. (Historic image, courtesy City of Lake Forest; contemporary image, courtesy Susan L. Kelsey.)

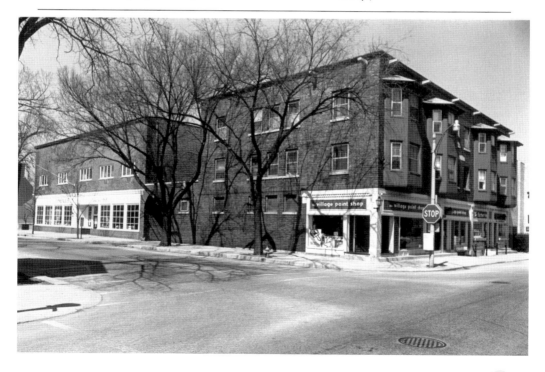

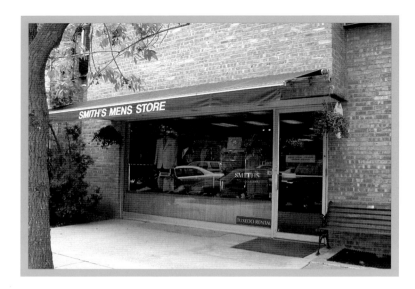

Smith's Mens Store, located at 770 North Western Avenue, specializes in men's clothing and outdoor gear. Previously it was located in Market Square. Robertson's started in 1929 and Smith's Mens Store opened in 1937. Pony Swanton bought Robertson's. Brooks Smith, a lifelong resident, was the owner of Smith's Mens Store. He and his wife, Jackie, spearheaded the drive to prevent Gorton School from being torn down. (Historic image, courtesy Shirley M. Paddock; contemporary image, courtesy City of Lake Forest.)

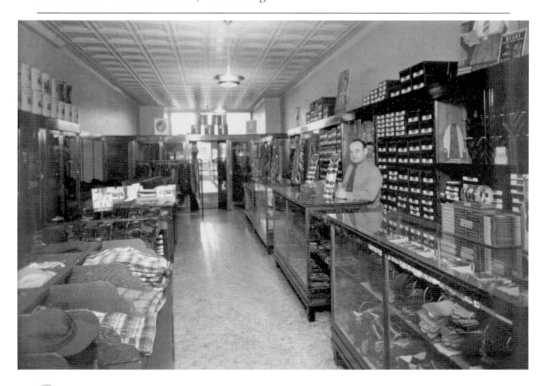

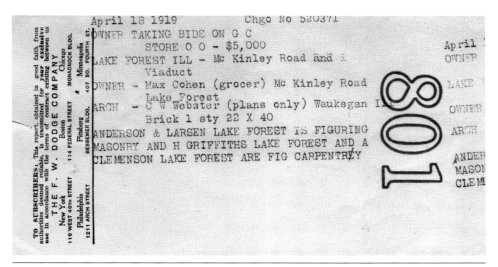

```
April 18 1919          Chgo No 520371
OWNER TAKING BIDS ON G C
       STORE O O - $5,000
LAKE FOREST ILL - Mc Kinley Road and
       Viaduct
OWNER - Max Cohen (grocer) Mc Kinley Road
       Lake Forest
ARCH  - C W Webster (plans only) Waukegan I
       Brick 1 sty 22 X 40
ANDERSON & LARSEN LAKE FOREST IS FIGURING
MASONRY AND H GRIFFITHS LAKE FOREST AND A
CLEMENSON LAKE FOREST ARE FIG CARPENTREY
```

```
April
OWNER

LAKE

OWNER

ARCH

ANDER
MASON
CLEM
```

Max Cohn came to Lake Forest in 1913 and opened his grocery store at 1005 McKinley Road, according to the *Lake Forester* on September 26, 1968. The architect was C. W. Webster, and it was constructed by Anderson and Larson Builders. After 55 years, Cohn and his wife retired, and the store became Carlo's Tailor Shop. (Historic image, courtesy Griffith, Grant and Lackie Realtors; contemporary image, courtesy Susan L. Kelsey.)

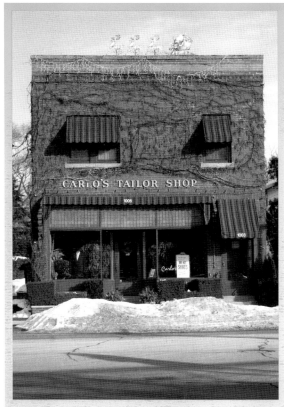

J. M. HANSEN

Manufacturer of high grade

MATTRESSES AND CUSHIONS

Lake Forest, Ill. Nov. 10, 1924 192

Constructed in 1921, the building housing Restona Mattress was located at 234 Wisconsin Avenue, now the Snowgate Antiques store. Restona Mattress made custom mattresses and cushions for the Deer Path Inn and other customers. Later the building was known for Hansen's Ivy Inn, owned by George Hansen and Cecil Hansen. (Historic image, courtesy Griffith, Grant and Lackie Realtors; contemporary image, courtesy City of Lake Forest.)

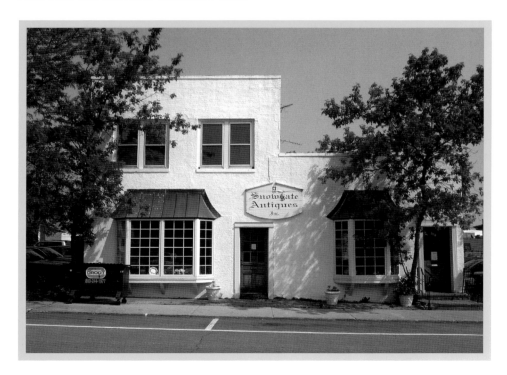

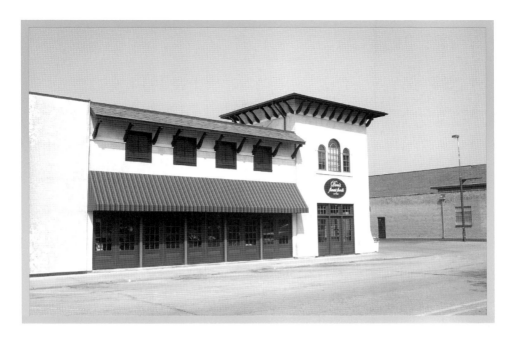

Don's Finest Foods, a local favorite, closed its doors in 2008. A family-owned grocery store for over 40 years with origins in Blackler's and Janowitz's meat markets, Don's catered many family holidays. Previously, the store in this location was known as A&P food store. (Courtesy City of Lake Forest.)

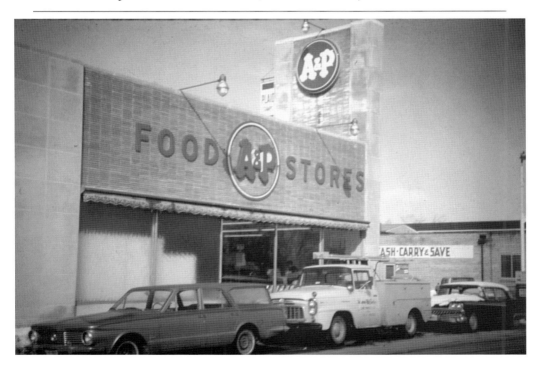

On the north end of Western Avenue, the business district had automobile dealers, service centers, and gasoline stations. The 1946 Boutin and Knauz building was converted in 2003 by Highview Partners into the Grille Restaurant. Another service station was owned by the Swarthout family, now Moncafe and Harris Bank on the southwest corner of Western and Wisconsin Avenues. (Historic image, courtesy Lenny Turelli; contemporary image, courtesy City of Lake Forest.)

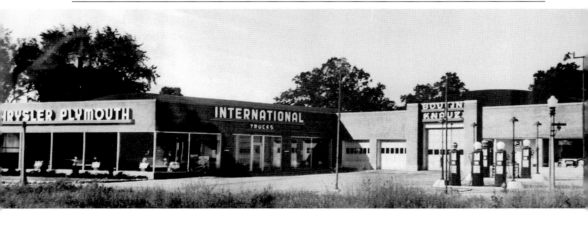

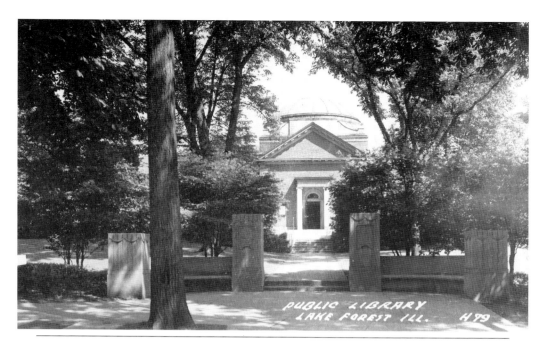

The present Lake Forest Library building was given to the city by Mrs. Charles H. Schweppe and Mrs. Kersey Coates Reed (later married to Stanley Keith) in memory of Reed's first husband, Kersey Coates Reed. It was dedicated on June 7, 1931. The original architect was Edwin Hill Clark. The 1970s landscape architect, following the addition of the east and west wings, was Franz Lipp. (Historic image, courtesy Shirley M. Paddock; contemporary image, courtesy Susan L. Kelsey.)

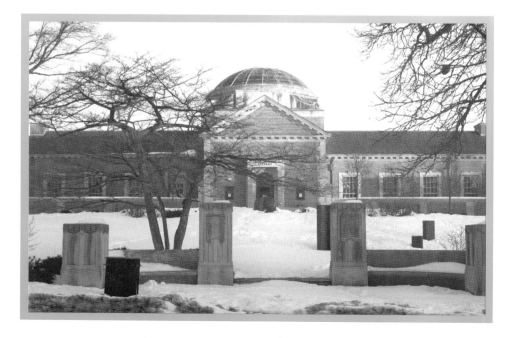

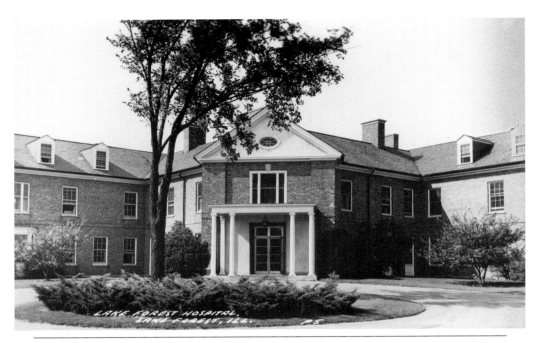

By 1899, Alice Home Hospital, designed by architects Frost and Granger, stood on the Lake Forest College campus and was expanded in 1916 to accommodate the growing population. In 1942, the Albert B. Dick family donated 25 acres to construct a new hospital, the Lake Forest Hospital, designed by Anderson and Ticknor. Today the campus includes the 215–bed community hospital, medical offices building, a health center, childcare center, and the Westmoreland Care Center. (Historic image, courtesy Lake Forest Archives; contemporary image, courtesy Shirley M. Paddock.)

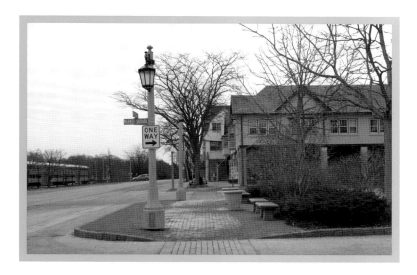

Standing on Western Avenue facing south, the pedestrian walkway is still an important feature in Market Square. As cars and delivery trucks changed over the years, the traffic pattern changed in the square. The front part of the green park was designed to be open to Western Avenue, beckoning passersby to visit the square. All year long, residents and guests enjoy sitting on benches, the children playing near the fountain, and employees enjoying the park during their lunch. (Historic image, courtesy Shirley M. Paddock; contemporary image, courtesy Susan L. Kelsey.)

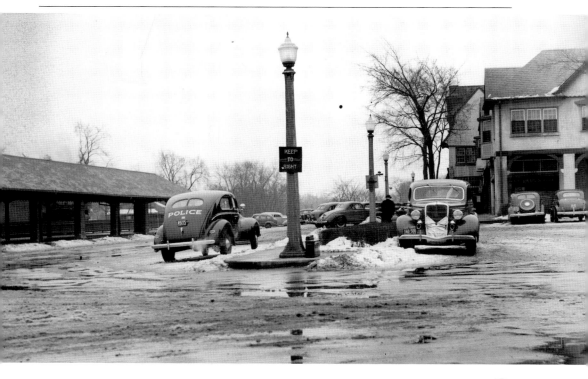

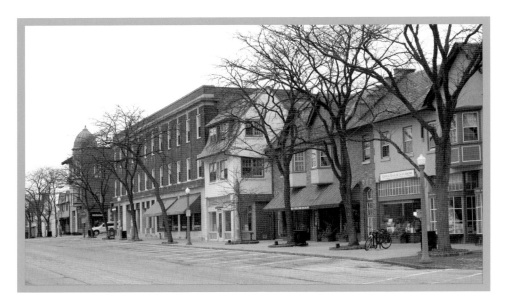

A 1917 map identifies all the businesses in the new Market Square, including a tire repair store, a grocery store, the post office, drugstores, a barber, a tea and coffee shop, a wallpaper shop, an upholstering shop, and many others that suited the needs of the elite local residents. Today Market Square has more specialty types of shops, and the north and south end of the district carry more of the convenience items. (Historic image, courtesy Shirley M. Paddock; contemporary image, courtesy Susan L. Kelsey.)

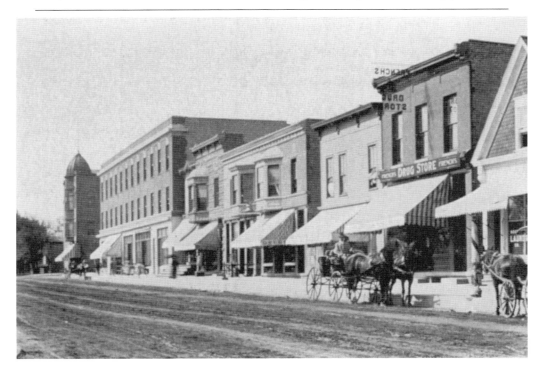

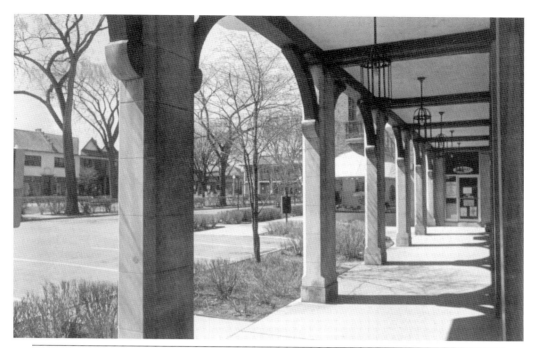

By the beginning of the 20th century, according to Robin Karson's *A Genius for Place*, country life had taken on an aura of romance and nostalgia. Olmsted writes, "scenes of landscape beauty could salve the troubled human psyche through unconscious or indirect recreation." Market Square was designed to be the heart of the community. According to Susan Dart in *Market Square*, the setbacks and cozy arcades invite and tempt with something more ahead. (Historic image, courtesy City of Lake Forest; contemporary image, courtesy Susan L. Kelsey.)

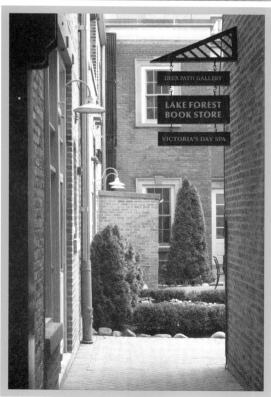

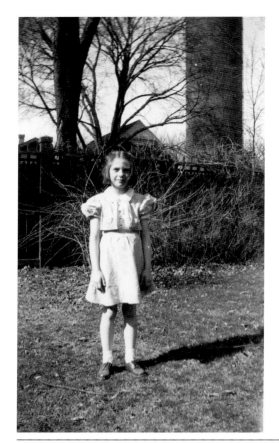

This photograph shows Shirley M. Paddock at age eight in 1942 in front of the old water tower that was located near city hall. Below, Paddock visits the tunnel under the east side train station, previously used to safely move passengers under the train tracks. (Historic image, courtesy Shirley M. Paddock; contemporary image, courtesy Susan L. Kelsey.)

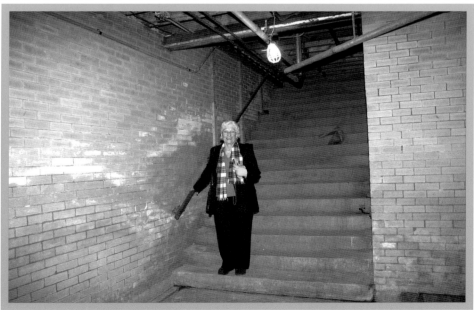

BIBLIOGRAPHY

Arpee, Edward. *Lake Forest Illinois, History and Reminiscences: 1861–1961.* Lake Forest, IL: Lake Forest-Lake Bluff Historical Society, 1991.

Coventry, Kim, Daniel Meyer, and Arthur H. Miller. *Classic Country Estates of Lake Forest: Architecture and Landscape Design, 1856–1940.* New York: W. W. Norton and Company, 2003.

Dart, Susan. *Market Square.* Lake Forest, IL: Lake Forest-Lake Bluff Historical Society, 1984.

Karson, Robin. *A Genius for Place: American Landscapes of the Country Place Era.* University of Massachusetts Press, 2007.

Miller, Arthur H., and Shirley M. Paddock. *Lake Forest: Estates, People, and Culture.* Charleston, SC: Arcadia Publishing, 2000.

Wendt, Lloyd, and Herman Kogan. *Give the Lady What She Wants!* Chicago: Rand McNally and Company, 1952.

White, Marion. *Second Book of the North Shore.* Chicago: J. Harrison White, 1911.

Wicht, Peter B. "The New Market Square at Lake Forest, Illinois: A Practical Illustration of Town Planning, Howard Shaw, Architect." *Western Architect* 26 (October 1917): 1–22.

ACROSS AMERICA, PEOPLE ARE DISCOVERING SOMETHING WONDERFUL. *THEIR HERITAGE.*

Arcadia Publishing is the leading local history publisher in the United States. With more than 3,000 titles in print and hundreds of new titles released every year, Arcadia has extensive specialized experience chronicling the history of communities and celebrating America's hidden stories, bringing to life the people, places, and events from the past. To discover the history of other communities across the nation, please visit:

www.arcadiapublishing.com

Customized search tools allow you to find regional history books about the town where you grew up, the cities where your friends and family live, the town where your parents met, or even that retirement spot you've been dreaming about.